EXPLORING
CAJUN
COUNTRY

EXPLORING
CAJUN
COUNTRY

A TOUR OF HISTORIC ACADIANA

Cheré Dastugue Coen

THE
History
PRESS

Published by The History Press
Charleston, SC 29403
www.historypress.net

First published 2011
Second printing 2015

Manufactured in the United States

ISBN 978.1.59629.995.5

Coen, Cher'e Dastugue.
Exploring Cajun Country : a tour of historic Acadiana / Chere Dastugue Coen.
p. cm.
Includes bibliographical references.
ISBN 978-1-59629-995-5
1. Cajuns--Louisiana--Social life and customs. 2. Louisiana--Social life and customs. 3.
Historic sites--Louisiana. 4. Louisiana--History, Local. 5. Louisiana--Guidebooks. I. Title.
F380.A2C64 2011
976.3--dc22
2011009605

Contents

Introduction

In 1604, a group of eager French citizens left their homeland for the shores of the New World, hoping to carve a new life from the vast wilderness. These hardworking farmers reached what is now the Maritime Provinces of Canada three years before Jamestown, four years before the settling of Quebec and fifteen years before the Pilgrims reached New England on the *Mayflower*.

Over time, more settlers arrived, building dykes to hold back the massive Bay of Fundy tides, an action that resulted in excellent farmland. Towns sprung up, forts were established and church parishes were created. The French pioneers called their new home *Acadie*, or Acadia.

Because of their isolation in the Canadian Maritimes and routine neglect from France, these hardy soles forged their way through the wilderness, connecting with neighboring Micmac Native Americans and developing a distinct identity. They became known as "Acadians."

As in Europe, there were constant wars between France and England in the New World, and the rich land that the Acadians reclaimed from the Bay of Fundy passed back and forth between the two nations as England and France took control of these North America territories. In the eighteenth century, England fully conquered the area. For the most part, the British allowed the Acadians to remain on their farms, and in doing so, the French-speaking Catholic residents prospered in these fertile lands.

In 1755, a shift in government occurred, and through a series of devastating actions the Acadians were collected, their homes and belongings were seized

and burned and they were shipped to the thirteen English colonies and the Caribbean, among other points south. Some ended up in English prisons, later to be repatriated back to France. Almost half of the deported Acadians died from disease and exposure aboard the ships during *le grand dérangement*, the name given to this hideous expulsion, one of the most egregious events in North American history. Many more died in poverty in exile.

At the time, Louisiana experienced its own power shift. When the Seven Years' War between France and England concluded, France had lost Canada and Louisiana east of the Mississippi (except for the "island of Orleans," or New Orleans). Spain, due to its family pact with France, lost Florida to the English. In a gesture of goodwill to its partner nation—although some may claim that France was happy to be rid of the troublesome colony—France ceded Louisiana to Spain in 1762.

Spain acquiring Louisiana actually made good sense, since Spain occupied the territories west of the Louisiana colony, a vast land that we now call Texas. And although the transfer of power was anything but pleasant for the *French* Louisiana citizens, Spanish rule lasted for thirty-four years, a time of remarkable growth and prosperity for Louisiana.

One aspect of the Louisiana colony did not change, however, and that was the fear of the English conquering the territory. England now controlled the land east of the Mississippi River, which included Baton Rouge, and Spain feared that they could easily take over New Orleans. Colonists loyal to France and Spain, notably Catholics, were encouraged to settle in Louisiana, helping to swell the ranks of local militias. Canary Islanders, for instance, were given land and equipment to farm lands near English forts along the Mississippi River, providing outposts in case of English attack.

Likewise, Acadians in exile were enticed to travel to Louisiana to start anew. Upon arrival, the Spanish government awarded them land grants, equipment and seed to start a new life. In waves, about one thousand displaced Acadians first arrived, settling in various locations throughout south Louisiana between 1757 and 1770. They arrived from the English colonies, Saint-Domingue (a French colony now called Haiti) and France. Some took farmland upriver above New Orleans, others traveled west to the Opelousas and Attakapas posts. The largest group—totaling 1,596 people—arrived between mid-May and mid-October 1785, settling in the southwestern region of Louisiana around today's Lafayette, Breaux Bridge and St. Martinville.

Today, descendants of these original Acadian pioneers to the Bayou State number close to a million. An equal number of Acadian descendants—those

CAJUN COUNTRY

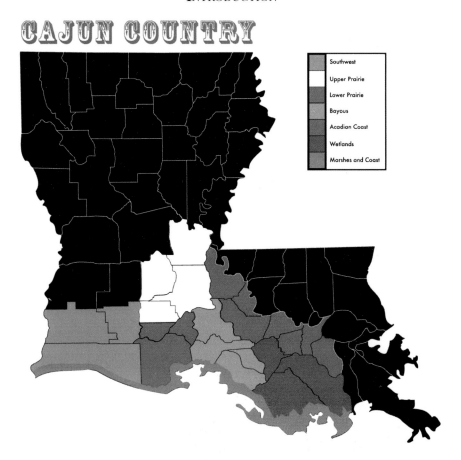

Acadiana Map. *Illustration by Sharon Bruno.*

who resisted capture or who were allowed back in restricted areas—today live in the Maritime Provinces of Canada.

In Louisiana, Acadians are labeled "Cajuns," an English corruption of their nickname "Cadjin" (pronounced "Cod-gen"). After the Louisiana Purchase in 1803, when Americans began migrating in great numbers to Louisiana, they heard this nickname and called the French-speaking residents "Cajuns."

The area known as Cajun Country in Louisiana includes all of south Louisiana, stretching up like a triangle to the middle of the state and reaching from the Mississippi state line to the Texas border. Locals call this the "French Triangle," an area rich in Acadian culture, great food, unique traditions and celebrations and people who work hard but at the

The twenty-two parishes
known as Cajun Country
are havens for nature lovers.

end of the day like to "pass a good time." In 1971, the Louisiana legislature deemed this vast region "Acadiana," although most Louisiana residents refer to only the southwestern area around Lafayette as Acadiana. Regardless, this heartland of displaced Acadians now called Cajuns includes twenty-two south Louisiana parishes: Acadia, Ascension, Assumption, Avoyelles, Calcasieu, Cameron, Evangeline, Iberia, Iberville, Jefferson Davis, Lafayette, Lafourche, Pointe Coupée, St. Charles, St. James, St. John the Baptist, St. Landry, St. Mary, St. Martin, Terrebonne, Vermilion and West Baton Rouge. For the purposes of this guide, I have divided Cajun Country/Acadiana into regions/chapters: the Acadian Coast, the Wetlands of Bayou Lafourche and Terrebonne Parish, the Bayou region, Upper Prairie, Lafayette, Lower Prairie, southwest Louisiana and the Louisiana coast.

Chapter 1
The Acadian Coast

L ouisiana hails back to the year 1699, when the Le Moyne brothers traveled down the Mississippi River from Canada and proclaimed the vast territory for King Louis XIV of France. Naturally, the early focus, whether it be for settlement or trading, was on the French colonial posts of Natchitoches and New Orleans.

Early settlers consisted of many farmers lured to the colony by promises of land and plenty, many of whom were Germans living in French territory due to European conflicts. These farmers settled above New Orleans along the Mississippi River in an area called the "German Coast" and farmed large stretches of land that helped to feed the struggling city.

When Acadians first arrived in the Louisiana colony, then under Spanish rule, they received land grants above these original Mississippi River settlements. The first Acadian settlements in Louisiana about 1765 were called St. Jacques de Cabannocé, and later, the "Acadian Coast."

Much of the state's early Acadian (Cajun) history can be found along the winding "River Road" of the Acadiana Coast on both sides of the Mississippi River above the city of New Orleans and south of Baton Rouge. In addition, visitors will find German, Spanish and American influences in the area, including Canary Islanders at Valenzuela near Donaldsonville and Galveztown at the confluence of the Manchac and Amite Rivers.

ST. GABRIEL

One of the first groups of Acadians to arrive in Louisiana from their place in exile in the Maryland colony settled on the east bank of the Mississippi River in the "Coast of Iberville," in Iberville Parish. About fifty Acadian families reached Fort San Gabriel de Manchac in July 1767. A Catholic parish was soon established and a church built from neighboring cypress swamps to accommodate these newcomers, who lived not too far from the Canary Islands settlement at Galveztown (now the town of Galvez). The church steeple was gifted to the St. Gabriel Catholic Church from the queen of Spain in 1770, and the Acadian church records from their original homeland of St. Charles Aux Mines of Nova Scotia were contained here.

"The residents of Spanish Manchac were taxed one and a half piastres for each front arpent of land they held to help build the church, and they also helped with construction," wrote Mary Ann Sternberg in *Winding Through Time: The Forgotten History and Present-day Peril of Bayou Manchac.* "Under the leadership

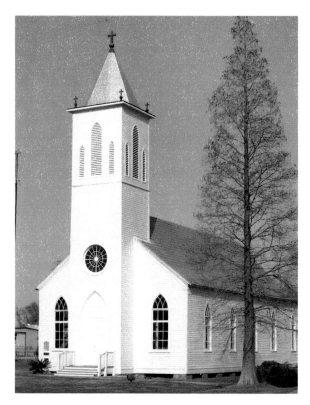

The St. Gabriel Catholic Church is believed to be one of the oldest churches in Louisiana, with the original bones of the first church concealed beneath the present façade.

of Louis LeConte, the selected contractor, the church of San Gabriel de Manchac was completed in August 1776. The simple Creole-style building of native cypress consisted of a small interior sanctuary, sixty feet by thirty-three and a half feet, surrounded on all sides by a dirt floored exterior gallery."

St. Gabriel Catholic Church is believed to be one of the oldest churches in Louisiana, with the original bones of the first church concealed beneath the present façade. The church bell, cast in Spain in 1771, remains, and in the rear of the property lies a peaceful cemetery containing many graves of pioneering Acadians (stgabrielcatholicchurch.com).

CARVILLE

To the south of St. Gabriel lies the town of Carville, for years a leprosarium where people were treated for Hansen's disease, commonly known as leprosy. The leprosarium was established in 1894 on the site of the Indian Camp Plantation. Today, the massive grounds are home to the National Hansen's Disease Museum, which gives a concise history of both the disease and the leprosarium. Located near the extensive hospital complex was once a settlement of early Acadians arriving in Louisiana at Point Clair, which existed in the bend of the Mississippi, just upriver from Carville (hrsa.gov/hansens/museum/tour-carville.htm).

CAJUN VILLAGE, SORRENTO

This collection of historic Cajun buildings makes a great place for tourists to stop and enjoy authentic rustic architecture, shopping that ranges from antiques to souvenirs and a bite to eat and a chance to view gators down a wooden pathway through marshlands. The Cajun Village Cottages offer accommodations in "Acadian-style shotguns," a narrow type of housing named because you can shoot a shotgun through the central hall in the home and not hit a wall. These buildings were relocated from a historic neighborhood in Baton Rouge, dating to about 1900, and are furnished with antiques (thecajunvillage.com).

The town of Sorrento owns a history like most of south Louisiana: French and Spanish in origins but eventually a gumbo of cultures. The town was first settled by Acadians but named by a German immigrant after the town in Italy where he took his wife on their honeymoon.

CONVENT

This River Road town acquired its name from St. Michael's Convent, established by the Order of the Sacred Heart. St. Joseph's School House, the first African American school in Louisiana, was built here in 1867 but has since been moved to the Cabin restaurant in Burnside. Still in Convent today is St. Michael's Church and, a few miles to the south, Jefferson College, established in 1831 for the education of local planters' children. The college went through different ownerships until it was closed in 1927. The Society of Jesus in New Orleans purchased the property and turned it into the Manresa Retreat House for men (manresala.org).

RIVER ROAD PLANTATIONS

Most plantations lining the River Road on both sides of the Mississippi in the parishes south of Baton Rouge and north of New Orleans were built and operated by the state's elite and not Acadians, historically. These exquisite homes are of great historic note, however, and several are included here, as visitors to Cajun Country will certainly pass them in their travels and will be intrigued enough to tour. By all means not a comprehensive list, the following are a few homes open to the public, particularly in the area known as the Acadian Coast.

Houmas House in Burnside is a magnificently refurbished grande dame with exquisite gardens and century-old oak trees that's popular for weddings and special events. Visitors can also enjoy dining at Café Burnside or the elegant, award-winning Latil's Landing Restaurant, in addition to touring the twenty-three-room mansion that dates back to the 1770s, with its impressive array of antiques, hallway mural and art collection. Houmas House was the site for the film *Hush...Hush, Sweet Charlotte* staring Bette Davis and Olivia de Havilland and the miniseries *North and South*.

Also located in Burnside on Highway 44 is the Cabin Restaurant, an old slave cabin that's been restored and filled with antiques, not to mention regional cuisine. Visitors can also dine inside the old L'Hermitage General Store, with its collectibles lining the wall, or the slave cabins from Helvetia Plantation. On site are numerous historic buildings, including the circa 1867 St. Joseph's School House built by the Sisters of the Sacred Heart and considered the first African American Catholic school in Louisiana. The school is a National Historic Property (thecabinrestaurant.com).

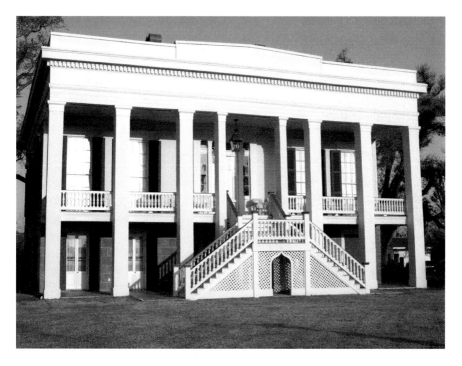

The 1837 raised Creole cottage of Bocage along the River Road near Darrow has been lovingly restored as a bed-and-breakfast.

Only a short ride down the River Road heading upriver is Bocage, an 1837 raised Creole cottage, also lovingly restored and filled with antiques, that serves as a bed-and-breakfast. The elegant home sits on 110 acres along the River Road, with lush gardens beckoning visitors inside. The name appropriately means "shady retreat," and the bed-and-breakfast makes for a great resting spot for visiting nearby attractions.

Oak Alley Plantation is recognizable for its long row of live oak trees seen repeatedly in films and commercials, not to mention the twenty-eight Doric columns surrounding the home's perimeter. Located in Vacherie on the west side of the Mississippi River, the Greek Revival home offers tours, dining and overnight cottages, not to mention a few residents who have passed on yet have not left the premises (oakalleyplantation.com).

Nearby, Laura Plantation is a Creole estate built in 1805 and includes land once owned by early Acadian settlers. The property has been renovated with the aid of namesake Laura Locoul Gore's extensive memoirs. The West African tale of *Compair Lapin*, known in English as "Br'er Rabbit," was recorded in one of the plantation's slave cabins (lauraplantation.com).

DONALDSONVILLE

At the town of Donaldsonville, the Mississippi River sends water down the long, winding Bayou Lafourche to the Gulf of Mexico. This confluence of the two waterways where the Chitimacha and Houma Native Americans held camp was called "La Fourche," which means "the fork."

The Acadians arrived in the Lafourche area between 1765 and 1766, with the Church of the Ascension created in 1772 under Spanish rule. Also settling the area were Canary Islands immigrants who, like the Acadians, were encouraged by the Spanish government to populate south Louisiana in an effort to ward off the British in nearby Baton Rouge and Manchac. The Canary Islanders' settlement of Valenzuela was located on the banks of Bayou Lafourche in what most believed to have been the site of Belle Alliance Plantation.

The town of Donaldsonville has its origins in 1806, when William Donaldson bought land in the area and developed a plan for "La Ville de

Historic downtown Donaldsonville includes museums, historic homes and businesses and a bed-and-breakfast. The town began in 1806, but much was destroyed in the Civil War. The historic district dates back to the Victorian era.

Donaldson," a town he felt was the perfect spot for the state's capital. The town founder got his wish, if only briefly. Donaldsonville was named the state capital in 1830, and the capitol building (built on land donated by Donaldson) was constructed on the south side of Louisiana Square. The legislature met there for one session and again for four days in 1831. The members soon longed for the excitement of New Orleans and moved the capital back that year.

Union forces occupied Donaldsonville during the Civil War, burning much of the town but sparing the church. They built a fort with which to defend the confluence of the Mississippi River with Bayou Lafourche, naming it Fort Butler after Union general Benjamin Butler, administrator of conquered New Orleans. In 1863, when the South attempted to take the fort, the U.S. forces, along with African American troops, held their ground and overwhelmingly defeated the Confederates. Today, a historical monument marks the spot, with tours of the area arranged (fortbutler.com).

After the Civil War, Donaldsonville rebuilt its downtown area, and today the fifty-block area between Church Street and Marchand Drive, with its nineteenth-century buildings, is known as the city's historic district. Visitors will find plenty of great historic architecture to enjoy, such the B. Lemann & Brothers Store on Railroad Avenue, built in 1877 by Bernard and Myer Lemann and at one time the oldest continuously operating department store in Louisiana. The River Road African American Museum offers exhibits on the contributions of the state's African Americans, including music, dance, storytelling and culinary traditions on the plantations, as well as slave records, attracting visitors from around the world (africanamericanmuseum. org). The center is included on the Louisiana African American Heritage Trail (astorylikenoother.com).

The 1889 Romanesque Revival Ascension Parish Courthouse offers tours of its interior, with a neighboring jail built in the 1860s.

King Charles III of Spain established the Church of the Ascension of Our Lord Jesus Christ in 1772, with records mentioning a church on this site and visiting priests administering to the Acadians as early as 1770. Its original name was *La Iglesia de la Ascension de Nostro Senor Jesu Cristo da Lafourche de los Chetimaches*, referring to the Chitimachas Indian tribe of the area. The first brick church was built on the site in 1819. A larger church, built in 1840, was spared during the Civil War, and the current structure was finished in 1876. Adjacent to the church is a historic cemetery, believed to be one of the largest and oldest Catholic cemeteries in the Diocese of Baton Rouge, used for years by Acadian exiles (ascensioncatholic.com).

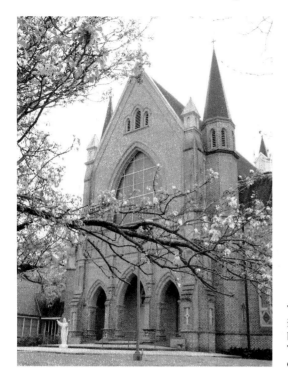

The Church of the Ascension in Donaldsonville was originally built for the Acadians in 1772. The current structure was completed in 1876.

Another historic religious structure, believed to be one of the oldest Jewish synagogues in America, is the Donaldsonville synagogue built in 1872 by Congregation Bikur Sholim, which disbanded in the 1940s. Today the building located across from Louisiana Square Park houses an Ace Hardware store, but the cemetery, founded in 1856, remains, with more than 120 graves.

The Grapevine Café and Gallery features fine dining in an Art Deco building once used as a gambling and drinking establishment during the Prohibition era. Al Capone was rumored to have visited "The Tavern," as the café was known then. Today, the restored building offers an insider's view into the construction of the building with its exposed brick and wood, and the café offers revolving gallery exhibits and acclaimed regional cuisine.

The Cabahanosse Bed-and-Breakfast reflects an early name of the Donaldsonville area, given to the region by the Choctaw tribe, meaning "sleeping place of the ducks." The 1890s bed-and-breakfast and antique store at 602 Railroad Avenue is listed on the National Register of Historic Places and was originally a general store in which the owners resided upstairs (cabahanosse.com).

Famous people who made Donaldsonville their home included Dr. Francois Prévost, a French doctor who performed successful caesarean sections and who is buried in the Church of the Ascension cemetery, and jazz greats "King" Joe Oliver, Kid Ory and Pierre Caliste Landry, a former slave elected as the first African American mayor of a U.S. city (Donaldsonville). Today, Donaldsonville is home to Chef John Folse, with his vast culinary operations, and self-taught primitive artist Alvin Batiste.

Bayou Lafourche was dammed in the early part of the twentieth century, ironically with bricks and other debris from the demolition of the unused state capitol building. For years, the bayou lay stagnant. Today, realizing the importance of silt making its way south to avoid coastal erosion, water is pumped from the Mississippi River into Bayou Lafourche, and visitors can view this at the two rivers' confluence.

GONZALES

This town, located halfway between New Orleans and Baton Rouge on the east side of the Mississippi River, is known as the "Jambalaya Capital of the World" and is home of the annual Jambalaya Festival. Every year on

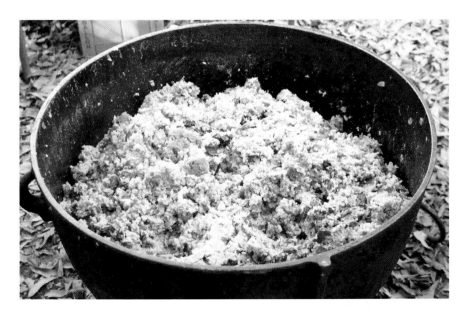

Jambalaya is a traditional Cajun dish with Spanish origins. The spicy rice dish created with chicken, sausage and sometimes seafood is based on the Spanish paella.

Memorial Day weekend, cooks travel to Gonzales with their massive cast-iron pots to cook up what they believe is the best jambalaya in the world. The Cajun/Creole rice dish consists of a mixture of meats and seasonings, and every cook in Louisiana boasts of theirs being the best. You don't have to wait until May to enjoy jambalaya, however; the traditional Louisiana dish can be found anytime in many Gonzales restaurants.

Gonzales was settled by and named for Spanish citizens who immigrated to south Louisiana to protect the Spanish colony from the British, in addition to Acadian refugees. Joseph Stonewall "Tee Joe" Gonzales, for instance, owned a general store and helped develop the town. His life and home, as well as area history, are part of the Tee Joe Gonzales Museum, located on the New River.

WHITE CASTLE

On the western side of the Mississippi lies the small town of White Castle, with sugar cane fields stretching into the horizon. Standing majestic among the farmland lies Nottoway, considered the South's largest antebellum plantation, built between 1848 and 1859 and containing sixty-four rooms. Nottoway offers overnight accommodations, tours of the main building (with candlelight tours on some evenings) and Ramsay's restaurant and lounge, which serves up a full plantation breakfast for overnight guests in addition to elegant lunches and dinners. Nottoway is a favorite spot for weddings, and there is a full-service spa on the property (nottoway.com).

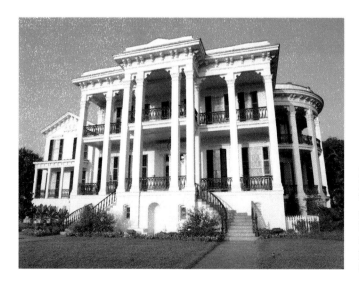

Nottoway Plantation in White Castle is considered the South's largest antebellum plantation, with its sixty-four rooms.

Sugar cane fields are plentiful in the southern region of Cajun Country.

BAYOU GOULA

About five miles south of Nottoway along the River Road lies arguably the "smallest church in the world." The Chapel of the Madonna is a staggering nine feet by nine feet, built in 1903 by Italian sugar cane farmer Anthony Gullo. The story holds that an ill Gullo prayed to the Virgin Mary for divine assistance and promised a chapel if he recovered. The tiny church was mentioned in *Ripley's Believe It or Not!* Mass is held once a year on August 15 to celebrate the Catholic Feast of the Assumption.

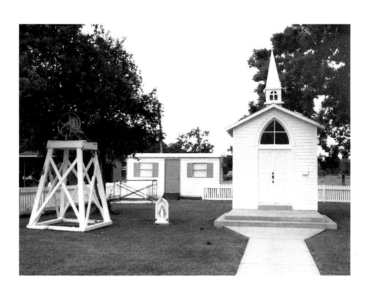

The Chapel of the Madonna in Bayou Goula is considered by some to be the "smallest church in the world."

PLAQUEMINE

Downtown Plaquemine offers a wide variety of historic attractions, with 120 structures listed in this National Register historic district. The best way to visit historic Plaquemine is to park your car at the Plaquemine Lock State Historic Site at 57730 Main Street, first enjoying this important structure that aided transportation along the Mississippi and was considered the highest freshwater lift of any lock in the world upon its completion in 1909. The Plaquemine Lock was designed by Colonel George W. Goethals, who later helped construct the Panama Canal. The site includes a museum, a visitor's center and an expansive open-air pavilion at the Bayou Plaquemine Waterfront Park to view both the Mississippi River and various watercraft used years ago.

Across the street, the Iberville Museum is located in the old parish courthouse (circa 1848) and exhibits artifacts of early Plaquemine and Iberville Parish history. Also opposite the Plaquemine Lock State Historic Site is St. John the Evangelist Catholic Church, built in the 1920s and a great example of Italian Romanesque architecture (plaquemine.org/departments/ Iberville-Museum), and the old railroad depot, which sells antiques.

For a sampling of historic Plaquemine architecture, head toward St. Basil's Academy at 32515 Church Street to view an 1850 mansion that was once a home but was later used by the Sisters Marianites of the Holy Cross until 1976. Nearby, there's the Fremin Home at 23520 Church Street, a typical 1800s Louisiana colonial raised cottage; the Queen Anne home at 57725 Court Street; First United Methodist Church; and the Iberville Chamber of Commerce housed in a 1904 building farther down on Church Street. On Eden Street, visitors will find the nineteenth-century Schwing/Middleton Home, damaged by cannon fire during the Civil War; Barker's Pharmacy, the oldest drugstore in the state; the Italianate Brusle-Stassi Building; and the circa 1899 People's Bank Building.

Located north of the Plaquemine Lock State Historic Site is Old Turnerville, a plantation once bounded by the Mississippi River, Bayou Plaquemine and Bayou Jacob that was later transformed into one of the city's first suburbs. The plantation was later subdivided into a neighborhood and is now one of the oldest in Plaquemine. Two houses of note are the raised cottage known as Marietta's House on Nadler Street—built in 1879 and the subject of a book by the same name written by J.E. Bourgoyne, the grandson of the original owner (margaretmedia.com)—and Miss Louise's House next door, an 1880s cottage.

Plaquemine translated to French means "persimmon" in the language of the Native Americans who first settled the area.

CINCLAIRE

Driving from Plaquemine upriver to Port Allen, visitors will notice the old and decaying Cinclaire Sugar Mill, once the Marengo Plantation and later the sugar plant, with its numerous structures built between 1855 and 1906. The complex is closed to the public.

PORT ALLEN

Port Allen is the heart of West Baton Rouge Parish, lying directly across the Mississippi from the state capital of Baton Rouge. The best place to learn of its history is the West Baton Rouge Museum, which contains a variety of authentic nineteenth-century structures, such as the 1830 French Creole–style Aillet House, the Allendale Plantation slave cabins and a 1904 working sugar mill model. The museum hosts special events, touring exhibits and educational programming (westbatonrougemuseum.com).

The Poplar Grove Plantation Home at 3142 North River Road was constructed as an Oriental-inspired pavilion for the 1884 World's Industrial and Cotton Centennial Exposition in New Orleans. After the fair closed, the home was transported upriver to its present site by barge. The home became the main residence to generations of the Wilkinson family, descendants of General James Wilkinson, first governor of the Upper Louisiana Territory (poplargroveplantation.com).

Other sites to consider in and around Port Allen are the Port Allen Lock, which connects the Mississippi River to the Intracoastal Waterway, shortening boat traffic to the Gulf by 120 miles; the Riverfront Development, offering picnic areas and viewing benches to watch boat traffic along the Mississippi River and view a stunning display of the Baton Rouge skyline; and Scott Cemetery, an African American burial site dating back to the 1850s located near the Riverfront Development.

In nearby Brusly, a massive live oak tree was the meeting place for the townspeople, who would leave messages to others in its trunk. Although messages are now left on a nearby bulletin board, the Back Brusly Oak remains and is believed to be more than four hundred years old.

Port Allen was named for the last Confederate governor of Louisiana, Henry Watkins Allen.

Chapter 2

The Wetlands of Bayou Lafourche and Terrebonne Parish

B ayou Lafourche breaks away from the Mississippi River at Donaldsonville, snaking its way through south Louisiana seeking a quick route to the Gulf of Mexico. Acadian settlers acquired Spanish land grants with access to the bayou, and towns grew horizontally along its banks. As the bayou meanders through several parishes in Cajun Country, it creates one long thoroughfare that folks in Louisiana call the "World's Longest Main Street."

"Bayou Lafourche, say Louisianians, is the longest village street in the world," wrote Harnett T. Kane in *The Bayous of Louisiana*. "For mile on mile, a single line of homes hugs the waterway on one bank, and sometimes on the other as well. Here and there towns appear, but often it cannot be determined when a town ends and mere residences on the bayou begin."

For years Cajuns had to boat to the other side and up and down Bayou Lafourche to meet with relatives, friends and business associates. When house dances were held, riders on horseback would traverse one side of the bayou and then another, calling out the time, date and place of the "fais do-do," named because the children would be put to sleep in one room of the house while the adults would then enjoy bowls of gumbo and dance in other rooms. "Fais do-do" in French means to be put to sleep, with "do-do" an abbreviation of the French verb *dormir*, to sleep.

Because of the Mississippi River water flowing through the area, and flooding fields during times of high water, the Lafourche region offered rich, fertile farmland. Early settlers found the area ripe for settlement, and later Acadians moved into the area hoping to carve out a life for themselves.

Bayou Lafourche breaks from the Mississippi River and meanders through several parishes to the Gulf of Mexico, flowing through many Cajun towns. It's been called the "World's Longest Main Street."

Some areas became natural spots for commerce. A tract of land on Bayou Lafourche owned by Henry S. Thibodaux evolved into a transportation hub for the movement of sugar, cotton and other goods between New Orleans, Donaldsonville and the western Teche country.

But let's start at the beginning of the longest street at Donaldsonville and make our way down.

PAINCOURTVILLE

The story goes that a steamer arriving in this Bayou Lafourche town couldn't find a loaf of bread anywhere, thus naming it a no-bread town—or the French equivalent. Whether that story is true, the Assumption Parish town was settled heavily by Acadian refugees, with the St. Elizabeth Catholic Church built in 1840 on land donated by Acadian Elizabeth Dugas. The present Gothic-style church was constructed in 1902 and contains beautiful stained-glass windows and ceiling frescoes of the church battling heresy.

PLATTENVILLE

On the other side of Bayou Lafourche lies Plattenville, with its Church of the Assumption of the Blessed Virgin Mary, constructed in 1856 and containing a painting of Mary's assumption. The original church on this site was the first Catholic church built on Bayou Lafourche, in 1793 by Spanish Capuchin priest Father Bernardo de Deva. Assumption Parish takes its name from this Catholic parish.

NAPOLEONVILLE

Another town with an unusual namesake—believed to have been named by a soldier who served under Napoleon Bonaparte—this parish seat includes Christ Episcopal Church, consecrated in 1853 by Leonidas Polk, named the "Fighting Bishop of the Confederacy" for his role in the Civil War. Other interesting places of worship include St. Anne Church (1874) and Immaculate Conception Chapel (1857).

The Madewood Plantation House in Napoleonville was built about 1846 as a sugar plantation and is today a National Historic Landmark and a bed-and-breakfast, with twenty-five-foot-high ceilings, a curved staircase and Corinthian columns (madewood.com).

PIERRE PART

Because of its relative isolation, Pierre Part remains predominately Cajun to this day, with many residents still speaking a unique form of south Louisiana French. The quaint town was recently highlighted in the TV show *Swamp People*. Pierre Part is located near beautiful Lake Verret, Bayou Corne, Grand Bayou, Belle River and other tranquil waterways known for great fishing and boating. Here, visitors can spot a lazy alligator warming in the sun, enjoy a swamp tour and hear authentic Cajun French being spoken.

THIBODAUX

Founded in 1830 after the death of Henry Thibodaux and the division of his property into town lots, Thibodaux fronts Bayou Lafourche, with a small historic district at its core. The town is home to Nicholls State University,

named for Francis Redding Tillou Nicholls, a former Louisiana governor, Confederate general, lawyer and graduate of West Point (nicholls.edu).

The Jean Lafitte National Historic Park and Preserve offers several sites throughout south Louisiana, including the French Quarter, the Barataria Preserve (where privateer Jean Lafitte smuggled goods into the state) and the Chalmette Battlefield and National Cemetery in Chalmette, where the Battle of New Orleans occurred. Throughout Cajun Country, the park offers the Wetlands Acadian Cultural Center in Thibodaux, the Prairie Acadian Cultural Center in Eunice and the Acadian Cultural Center in Lafayette. All three showcase the traditions of the Acadians (Cajuns) with exhibits on settlement patterns, history, music, Mardi Gras, dancing, food, crafts such as weaving and industry such as wooden boat building. The Jean Lafitte Wetlands Acadian Cultural Center offers a great overview of the Cajuns who settled among the southeastern bayous and marshlands. The center hosts Cajun jam sessions, boat tours along Bayou Lafourche and lessons in traditional Cajun boat building, much of which is passed on from generation to generation verbally.

The Wetlands Acadian Cultural Center in Thibodaux, part of the Jean Lafitte National Historic Park and Preserve, offers cultural classes such as traditional Cajun wooden boat building.

A Tour of Historic Acadiana

Thibodaux's historic downtown contains such gems as the three-story Dansereau House Bed-and-Breakfast, once owned by Dr. Francois Philippe Dansereau, who watched for distress signals from his rooftop cupola. If a light arose in town, he knew that his services were needed.

Historic churches of note are the St. Joseph Co-Cathedral, with its impressive architecture and magnificent stained glass, and the 1844–45 St. John's Episcopal Church, the oldest and first Episcopal church building west of the Mississippi River, organized by Thibodaux native Leonidas Polk, named the "Fighting Bishop of the Confederacy" for his role in the Civil War.

Thibodaux was home to Edward Douglas White, the only chief justice of the United States from Louisiana and a native of Lafourche Parish. His raised cottage of pegged cypress has undergone renovation and is available to the public through the Louisiana State Museum. This Historic Landmark believed to have been built in the early 1800s fronts Bayou Lafourche at 2295 Louisiana Highway 1.

Another interesting resident of the region was Jim Bowie, hero of the Alamo. He and his brother purchased land along Bayou Lafourche near Thibodaux and built Louisiana's first steam-powered sugar mill, according to Paul Stahls's *Plantation Homes of the Lafourche Country*. Jim Bowie purchased a plantation named Acadie but changed it to Acadia. After his death at the Alamo, Acadia was sold to Philip Barton Key, nephew of Francis Scott Key, author of the national anthem, *The Star-Spangled Banner*, and later Andrew Jackson Donelson, nephew of Rachel Jackson, wife of Andrew Jackson, according to Stahls. Jim Bowie's house and those of the rest of the family were later consolidated into one home. Today, the plantation is the site of a traditional neighborhood development project called Acadia Plantation.

Dating back to 1785, Laurel Valley Plantation is the largest surviving sugar plantation complex in the United States, with 60 of the original 105 structures still standing today on the property. The general store contains many tools and farm implements used in the cultivation of sugar cane, as well as locally made arts and crafts. Visitors may tour the plantation on their own or arrange for a guided tour by reservation.

Note that most Cajuns named "Thibodeaux" do not spell it the same way as the town.

RACELAND

Raceland native Freddie John Falgout was a sailor aboard the USS *Augusta* in 1937 and received a stray shell from a Japanese warship heading toward a Chinese target. Falgout is considered the first American casualty of World War II, and thus the subject of the First American Casualty of World War II Memorial at the Lafourche Visitor Welcome Center in Raceland. His tomb can be visited at the St. Mary's Nativity Church Cemetery, five miles north on Louisiana Highway 1.

LOCKPORT

Originally called Longueville, the town changed its name after a waterway linking Bayou Terrebonne with New Orleans, with locks at Longueville, was completed. The town enjoyed prosperity through bayou trade until a levee break caused the locks to be closed in 1876. Today, the town's commerce relies on fishing, the oil and gas industries and growing sugar cane.

The Bayou Lafourche Folklife and Heritage Museum within the old Merchants and Planters Bank on the National Register of Historic Places features a history of Bayou Lafourche, plus rotating exhibits (bayoumuseum.org).

HOUMA

Houma is another bayou town, named for the resident Houma Indian tribe and situated on the slow-moving Bayou Terrebonne, which washes out to the Gulf of Mexico. Wetlands, marshes, swamps and canals surround the quaint Cajun town, sometimes called the "Venice of America" and the "Heart of America's Wetlands." Houma sits within Terrebonne Parish, a fragile corner of Louisiana where more than thirteen square miles were lost in Hurricanes Katrina and Rita alone. Although land loss is prominent throughout the coast of Louisiana (twenty-five square miles per year), Houma has become a staging ground for activism and change, including the Voice of the Wetlands Festival, started by Houma blues musician Tab Benoit and held every October (voiceofthewetlands.org).

Terrebonne Parish means "good land" in French, and settlement along this fertile soil south of New Orleans began in 1822. Most settlers of

A Tour of Historic Acadiana

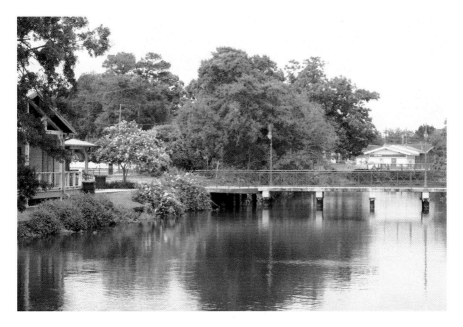

The town of Houma is located on the slow-moving Bayou Terrebonne, which connects to the Gulf of Mexico.

both the parish and the city were French and Spanish citizens from New Orleans, Acadians from exile and other nationalities such as German, Italian and Africans.

For many years, Houma and Terrebonne Parish remained a sugar hub, boasting of hundreds of sugar plantations with water access to markets and an easy trip to New Orleans, about sixty miles to the north. In later years, Houma would also become a hub for the oil, gas and seafood industries.

Visitors to Houma will find many historic homes and churches, as well as a vibrant Mardi Gras scene with numerous krewes, balls and fifteen parades. Best of all, a visit to Houma for the annual Mardi Gras costs less than New Orleans, with a safer experience for families.

For a great history of the Houma region, the first stop should be Southdown Plantation House and the Terrebonne Museum at 1208 Museum Drive, under the direction of the Terrebonne Historical and Cultural Society. The exhibits on Houma history and culture, life in the nineteenth century, Mardi Gras traditions and more are contained within an 1859 sugar plantation manor house. Tours of the house are available, and an arts and crafts festival is held twice a year on the property, in the spring and fall (southdownmuseum.org).

The Louisiana iris is a native plant found throughout Cajun Country's swamps, marshlands and bayou sides.

The Bayou Terrebonne Waterlife Museum at 7910 Park Avenue offers visitors interactive displays of the history of Terrebonne Parish, plus the region's economy and culture. There are many exhibits showcasing regional businesses such as oil, gas and seafood industries, as well as the effect of hurricanes on the local ecosystem. The forty-six-foot *Wetlands Wall* piece by acclaimed Lafayette muralist Robert Dafford explains Louisiana's wetlands, from the deep waters of the Gulf and its barrier islands up through the coast marshes, swamps and into the high country, still only a few feet above sea level. The building that houses the museum is an 1880s warehouse once used by Daigle Barge Lines (terrebonnewaterlifemuseum.org).

The Terrebonne Folklife Culture Center at 317 Goode Street displays local folk art, features three historic permanent displays and offers weekly classes in Cajun dancing, duck decoy wood carving, quilting, Cajun French, square dancing, knitting and crocheting (terrebonnefolklife.org).

Listen to veterans of America's wars recount their stories at the Regional Military Museum at 1154 Barrow Street. Here visitors will find various

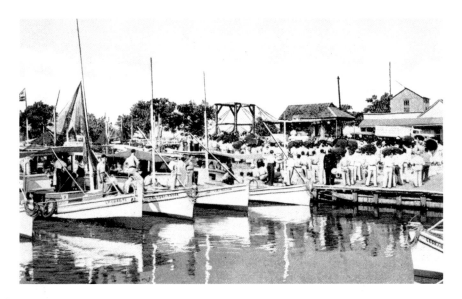

This old postcard shows the annual blessing of shrimp trawlers at the Boudreaux Canal Store near Houma.

uniforms, weapons and both model-size and full-size military vehicles, plus an extensive library of war-related books. In addition, the museum schedules special events (regionalmilitarymuseum.com).

GIBSON/BAYOU DULARGE

In addition to swamp tours leaving out of Houma, visitors can head out to the more rural areas of Gibson and Bayou DuLarge, where tour guides will lead them through swamps and marshlands for an up-close and personal look at Louisiana's unique and valuable wetlands. Tours range from viewing alligators and the defunct logging town of Donner to educational tours that spotlight the importance of America's wetlands and Louisiana's ongoing fight to save the state's coastline from erosion and pollution. There's also the Wildlife Gardens on Bayou Black in Gibson, which offers both a bed-and-breakfast and a chance to view alligators through a cypress swamp. The best place to find a comprehensive listing of swamp tours and charter fishing is to visit the Houma Area Convention and Visitors Bureau at houmatravel.com.

MARDI GRAS

In south Louisiana, natives don't waste much time after the Christmas holidays before gearing up for more revelry. The season of Carnival officially begins on January 6, also known as the Epiphany, King's Day or Twelfth Night, the day the magi greeted the Christ child in Bethlehem with gifts.

January 6 also signifies the twelfth day of Christmas and the end to that holiday season and the beginning of a new one known as Carnival, a period of feasting before Lent that culminates with Mardi Gras, the Tuesday before Ash Wednesday.

"The Catholic Church licensed Carnival, which means 'farewell to flesh,' as a period of feasting before the fasting of Lent," explains Arthur Hardy in *Mardi Gras in New Orleans: An Illustrated History*. "The

Many towns in Cajun Country offer Mardi Gras celebrations, whether parades hosted by krewes, such as this Lafayette parade, or the ancient *courir de Mardi Gras*, where costumed men and women on horseback travel the countryside begging residents for ingredients to a gumbo.

Church also established the set date for the start of the Carnival season—Jan. 6, the Feast of the Epiphany—and the fluctuating date of Mardi Gras."

During the Carnival season, social organizations known as "krewes" conduct formal balls and announce the royalty who will reign over their krewes for the year. They usually celebrate around a theme, with costumes reflecting this story. Then, closer to Mardi Gras, the krewes parade through the towns throwing beads and other trinkets to a grateful audience lining the parade routes.

The whole affair culminates at Mardi Gras, otherwise known as Fat Tuesday, a date that fluctuates every year because it is connected to Easter (both holidays are based on the lunar calendar). At midnight, when Mardi Gras morphs into Ash Wednesday, the feast of Carnival concludes and the fasting of Lent commences.

Although the world sees Mardi Gras as a massive celebration in New Orleans, towns across Louisiana celebrate both Carnival and

The Mardi Gras Museum located in the Central School Arts and Humanities Center of Lake Charles showcases the many Carnival traditions of southwestern Louisiana, including the Cajun *courir de Mardi Gras*.

Mardi Gras as well. In Lafayette, Houma and Lake Charles, there are numerous krewes offering elaborate balls and parties, followed by street parades. Many tourists, especially those with families who wish for a smaller and safer version of the New Orleans spectacle, choose these cities to view Mardi Gras.

Also, in Cajun Country, many towns celebrate the ancient Carnival tradition of *courirs*, during which costumed men and women on horseback travel the countryside to beg residents for ingredients to a gumbo, usually with a musical band and onlookers following behind. Once they arrive in town, a communal gumbo is cooked, enjoyed and then served to the town's residents. This unique Carnival tradition's full name is *la courir de Mardi Gras*, meaning the "running of the Mardi Gras."

"The course's roots lie in the medieval *fête de la quémande*, a ritual begging festival," writes historian Shane Bernard in *Cajuns and Their Acadian Ancestors*. "Remnants of this medieval tradition include the wearing of pointed hats, miters, and mortarboards to mock the wealthy, the ordained, and the well educated. Most costumes are homemade and extremely colorful, and they allow individuals to poke fun at the usual social order."

Les courirs de Mardi Gras are completely different from town celebrations.

Chapter 3
The Bayous

The story has it that the sleepy, meandering Bayou Teche running through south-central Louisiana means "snake" in the Chitimacha language, and it's easy to see why. The quiet waterway has its origins in larger thoroughfares, the ancient Mississippi River and the Red, and it winds its way down from larger streams to the Gulf of Mexico. The Chitimacha legend contends that the Teche was originally a massive snake, which took many warriors to conquer and with much resistance. As it twisted and turned in rebellion of the tribal warriors, the snake left a long, winding path in its wake. Today, the Bayou Teche literally snakes its way southward, but at a much slower pace than it did hundreds of years ago.

The region is home to many cultures, but certainly those of Cajuns and Creoles. "Today over the Teche spreads an alternation of elements—one part that of the older Creoles; another, that of the Acadians; but predominant over many miles, that of the Anglo-Saxons," wrote Harnett T. Kane in *The Bayous of Louisiana*. "The various groups settled near each other and competed for dominance. The result is often a curious juxtaposition—a strongly Southern-American town next to a cluster of small Acadian homes, and then a grande maison bearing a shining name of Creole civilization."

The Teche region neighbors the massive Atchafalaya Basin, the largest freshwater river drainage swamp in North America. Encompassing almost a million acres of swamps, lakes and water prairies, the Atchafalaya Basin teems with wildlife. Both the basin and Bayou Teche were important waterways leading into the western regions of the Louisiana territory for nearly two

hundred years, and both were popular hunting and living grounds for the Attakapas and Chitimacha native peoples and then later the Cajuns, among other settlers.

The Atchafalaya National Heritage Area was established in 2006, encompassing fourteen parishes in south-central Louisiana (atchafalaya.org). The Bayou Teche Scenic Byway winds 125 miles through three parishes: St. Mary, Iberia and St. Martin (byways.org/explore/byways/2066).

THE LEGEND OF EVANGELINE

As travelers wander throughout Cajun Country—the twenty-two parishes making up French south Louisiana—there are constant reminders of the origins of the Acadian people, although Canada is as far from the minds of Cajuns as is it geographically. Cajuns share their love of their culture and traditions with their cousins in New Brunswick, Nova Scotia and Prince Edward Island, but they are not ones to dwell on the past and the horrible expulsion beginning in 1755 by the British that ultimately landed them on the shores of Louisiana.

Still, one symbol of their past remains dear to the hearts of both Acadians of Canada and Cajuns of Louisiana: the legend of Evangeline.

Henry Wadsworth Longfellow wrote the poem *Evangeline: A Tale of Acadie* after graduating from Bowdoin College in Maine and moving to Boston to teach at Harvard. It was a creation that changed his life. The hexameter verse of an Acadian girl separated from her intended during *le grand dérangement*, or the great exile of the Acadian people from their homeland in Nova Scotia, made the young poet famous.

Evangeline also brought to light the horrible treatment of the Acadians by the British when they were removed from the Maritimes of Canada. Until 1847, when the poem was published, very few North Americans knew of the British action to rid Nova Scotia and surrounding areas of the Acadians, sending them into exile throughout the thirteen British colonies, the Caribbean and other points south, as well as prisons in England and poverty in France.

The poem follows the lives of Evangeline and Gabriel, two young lovers planning their wedding and life together in Grand Pré, Acadie, known by the occupying British as Nova Scotia. When the British

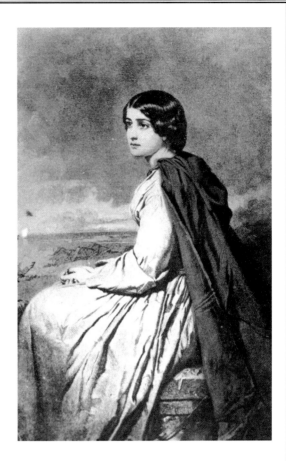

Evangeline, Henry Wadsworth Longfellow's heroine in a poem of the same name, was the subject of this early twentieth-century postcard. Evangeline continues to be a beloved symbol of Cajun history.

force the Acadians from their lands and exile the peaceful residents to the American colonies and other far-off ports, Evangeline and Gabriel are separated. Evangeline lands in Louisiana only to hear that Gabriel had arrived and left when he realized that his love was not in the colony. Evangeline then begins a lifelong search for Gabriel through the American frontier, eventually joining the Sisters of Mercy in Philadelphia until old age, when she finds Gabriel on his deathbed in a hospital. The two lovers have a moment together at last, but then their reunion is tragically destroyed by Gabriel's death.

It is believed that Longfellow heard a similar story of an Acadian woman and her intended separated on the day of their wedding at a dinner about 1840 with Reverend Horace Lorenzo Conolly and

Longfellow's friend, American writer Nathaniel Hawthorne. Conolly wanted Hawthorne to write the story, but he refused; Longfellow accepted the challenge instead. It was the first hexameter verse to be written in English and became a hit for the young poet, selling almost thirty-six thousand copies by 1857 and elevating him as the most famous writer in America during that time.

More than one hundred versions of the poem have been published, and two movies, both filmed in the 1920s, were made. The most famous film was the 1929 version starring Delores del Rio filmed in St. Martinville. A statue of Evangeline, created with Del Rio as a model, exists on the grave of Emmeline Labiche, a St. Martinville woman whom Louisiana judge Felix Voorhies believed was the source of the story; he claims so in his 1907 book, *Acadian Reminiscences: The True Story of Evangeline*. Near the St. Martinville grave site is the "Evangeline Oak," said to be where Labiche waited patiently for her Gabriel, a man named Louis Arceneaux, until she went insane after finding out that he married another. Louis Arceneaux's residence, titled BeauBassin after his Canadian Maritime home, exists at Vermilionville, and the home's original historical marker out front reads: "Here Louis Pierre Arceneaux, prototype of Longfellow's Gabriel, established his ranch

This old postcard shows the Evangeline Oak tree in St. Martinville in the 1930s.

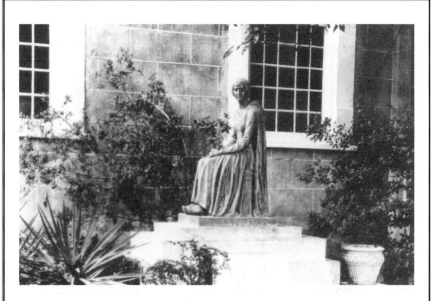

Actress Delores del Rio posed for this statue of Evangeline, which marks the grave of Emmeline Labiche, reportedly the inspiration for Longfellow's poem.

in 1765." Also in St. Martinville is Louisiana's first state park, the Longfellow-Evangeline State Historic Site.

Today, more than 150 years after the poem was published, the legend of Evangeline continues. Throughout Acadiana, or south Louisiana's Cajun Country, ties to the popular American poem remain. Visitors will find Evangeline Maid Bread, Evangeline Thruway, the Evangeline Downs racetrack, the town of Evangeline and Evangeline Parish, among so many others.

ST. MARTINVILLE

French and Spanish colonialists settled along Bayou Teche near what is now St. Martinville before the arrival of the Acadians beginning in 1764. Spanish-speaking Malaga settlers, refugees fleeing the French Revolution and New Orleans residents hoping for Spanish land grants arrived as well. In fact, the 1766 census of the area lists both Creole and Acadian households, in addition to black and Native American slaves. Many of those hailing directly from France and Spain and considered Creole (as opposed to Acadians who arrived from exile after living in the Maritime Provinces of Canada) became wealthy and owned vast stretches of land while supporting theater and opera in town. Their elaborate livelihoods prompted visitors to call St. Martinville "le Petite Paris."

Most Acadians settled outside the city limits of St. Martinville, but a church was established here to accommodate the newly arrived French exiles. The French priest in charge, Father Jean Louis Civrey, called his new home "la nouvelle Acadie," or "New Acadia." His parish became St. Martin de Tours, which is where St. Martinville acquired its name.

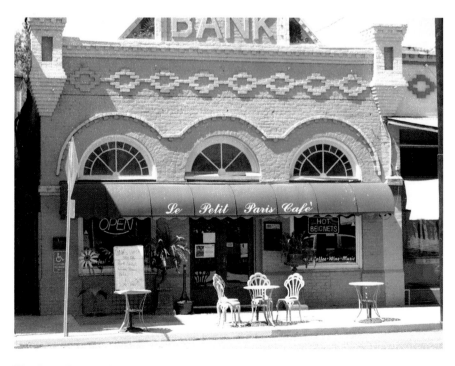

The Petite Paris Café is one of the many businesses operating in the historic square of St. Martinville.

A Tour of Historic Acadiana

Today, visitors from around the world visit St. Martinville to view its Acadian and Creole history and the church known as the "Mother Church of the Acadians" and to sit beside the ancient Evangeline Oak. Although Henry Wadsworth Longfellow heard a story of a young woman torn from her lover during the Acadian *grand dérangement* and wrote the tale as the poem *Evangeline*, he never actually visited Louisiana. Still, in the poem Longfellow states that the main character Evangeline waited for her financé Gabriel beneath an oak tree in St. Martinville. This ancient tree still living on the shores of Bayou Teche remains today as the symbol of the lovers torn apart by politics and is a favorite among tourists.

The elegant St. Martin de Tours Catholic Church located inside the majestic square at the heart of St. Martinville was established in 1765, although church records date back even further. The Gothic Revival building was constructed in 1844 and today remains the "Mother Church of the Acadians," with guided tours given and Masses held in both English and French.

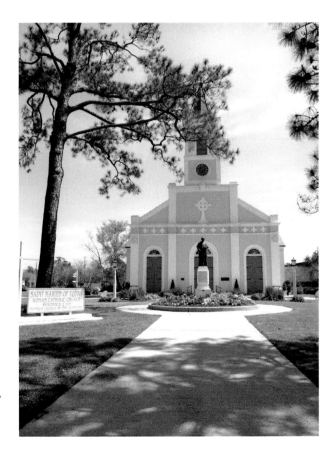

St. Martin de Tours Catholic Church in the heart of St. Martinville was established in 1765, considered today to be the "Mother Church of the Acadians."

Next to the church is the cemetery where many of the town's pioneers are buried. The most popular grave, however, is that of Emmeline Labiche, a woman separated from her lover, Louis Arceneaux, during the Acadian exile, according to Felix Voorhies, who wrote about Labiche's story in *Acadian Reminiscences: The True Story of Evangeline*. Voorhies was convinced that Labiche's story was the genesis for Longfellow's *Evangeline* and wanted to set the story straight with his 1907 book. In Voorhies' tale, Labiche waited by the oak tree along Bayou Teche for Louis Arceneaux, only to find Louis had remarried. Deprived of all hope, Labiche lost touch with her sanity and died. The grave site of Labiche is topped by a statue of Longfellow's character Evangeline. Actress Delores del Rio posed for this statue when she was in St. Martinville filming the 1929 film *Evangeline*.

Evangeline Oak Park contains the Evangeline Oak, the Bayou Teche boardwalk along the water's edge, the St. Martinville Cultural Heritage Center, the Tourist Information Center and Evangeline Boulevard.

The St. Martinville Cultural Heritage Center at 125 South New Market Street is home to the African American Museum and the Museum of the Acadian Memorial—one tells the story of Africans coming to Louisiana and their history thereafter, while the other explains the history of the Acadian people torn from their homeland who regrouped on the shores of Bayou Teche and started anew. The Acadian Memorial features a Wall of Names with three thousand Acadians listed, an Eternal Flame that signifies the ability of a people and culture to rekindle in their new home, a Robert Dafford mural showcasing *The Arrival of the Acadians in Louisiana* about 1785 using modern-day descendants as models for the mural's characters (its twin mural in Nantes, France, depicts the exiled Acadians leaving that port city for St. Martinville) and a multimedia center and museum. Both museums offer special events and cultural celebrations (acadianmemorial.org, dssnet. net/african%20american).

Traveling theatrical companies of the nineteenth and twentieth centuries would stop at the elegant Duchamp Opera House, built in the 1830s on the square in St. Martinville. The building at the corner of Main and Port Streets has been restored and is now used by the Evangeline Players theater troupe with a cooperative arts gallery downstairs (evangelineplayers.org).

A few miles from the center of town is the Longfellow-Evangeline State Historic Site, originally a *vacherie* (cattle ranch) and then an indigo and sugar cane plantation. Pierre Olivier Duclozel de Vezin inherited the property in the early 1800s, and it is his house that exists there today, used as an educational tool in showcasing how Creoles lived in the nineteenth century.

A Tour of Historic Acadiana

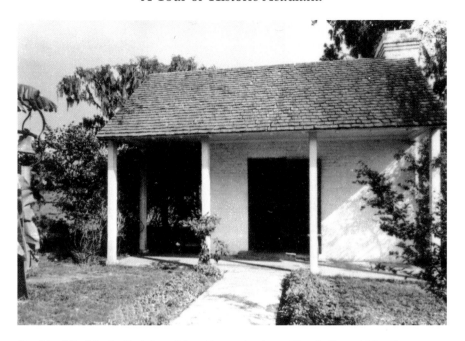

Outside of St. Martinville is Longfellow-Evangeline State Historic Site, which offers an authentic Cajun cabin and homestead.

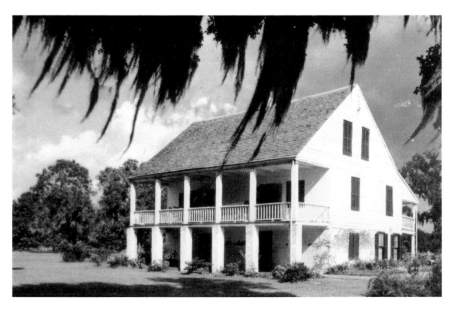

The Pierre Olivier Duclozel de Vezin House at Longfellow-Evangeline State Historic Site gives visitors a glimpse into the life of area residents in the 1800s.

The raised Creole cottage contains a fourteen-inch-thick ground floor wall made from Bayou Teche bricks and *bousillage*, a mixture of Spanish moss and mud insulation. The house is filled with period antiques. Also located in the park is a rustic Cajun cabin equipped with Louisiana cypress furniture and a farm homestead, as well as the "Gabriel" live oak tree.

THE NATIONAL DAY OF THE ACADIANS

The National Day of the Acadians, held to commemorate the deportation from Nova Scotia that resulted in Acadians (Cajuns) arriving and settling in Louisiana, is celebrated every year on August 15, the Feast of the Assumption of the Blessed Virgin Mary. The event is held both in the Maritime Provinces of Canada, where the Acadians first settled after leaving France for the New World, and in the region known as Acadiana, Louisiana, where the largest group of exiles arrived in the late 1700s.

In St. Martinville (about thirty minutes from Lafayette), a celebration takes place at the Acadian Memorial and Museum and includes the

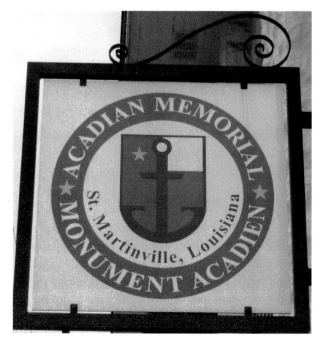

The Acadian Memorial in St. Martinville tells the history of the Acadian people torn from their homeland who regrouped on the shores of Bayou Teche and started anew.

ceremonial raising of the Acadian flag, children's stories, a film on the Acadian story, picnicking on the boardwalk overlooking beautiful Bayou Teche and theatrical performances. There is an annual procession in which families carry their family banners from the Acadian Memorial to St. Martin de Tours Catholic Church. The day usually ends with a French Mass at St. Martin de Tours, the "Mother Church of the Acadians" and one of the oldest Catholic churches in Louisiana.

The Acadian Memorial is located at 121 South New Market Street in St. Martinville.

LAKE FAUSSE POINTE

East of New Iberia, near the town of Loreauville, is one of Louisiana's best-kept secrets. The six-thousand-acre Lake Fausse Pointe State Park features boating of all kinds, camping out in cabins and more primitive methods, plus swimming in the tepid Lake Fausse Pointe. The area was once connected to

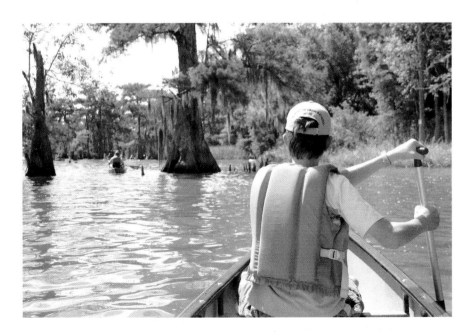

This page and next: Lake Fausse Pointe east of New Iberia is a favorite among canoeists and home to some of the state's last giant cypress trees.

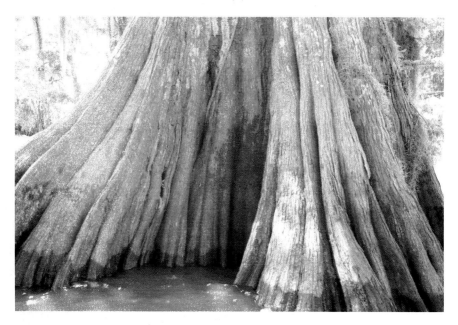

the nearby Atchafalaya Basin, the largest freshwater river drainage swamp in North America, then home to the Chitimacha tribe until French, Spanish and Acadians entered the region. The logging industry around the turn of the twentieth century dominated the swampy forests, felling many of the giant cypress trees that grew there, rumored to be hundreds of years old. However, a lone grove of these giants exists on the outskirts of Lake Fausse Pointe and can be reached by boat.

A fantastic way to enjoy the great outdoors of Cajun Country is to camp at Lake Fausse Point, rent a boat at park headquarters, explore the bayous and lakes and witness these massive trees. Along the way, visitors are sure to spot alligators and other native creatures and may be surprised to find them as scared of you as you are of them (crt.state.la.us/parks/ilakefaus.aspx).

BREAUX BRIDGE

After Firmin Breaux and his parents were expelled in 1755 from their homeland in Acadia, the Maritime Provinces of Canada, they landed at Boston in the Massachusetts colony. Breaux's parents eventually made their way back to Canada, but Firmin headed for the Louisiana colony. He settled in the Bayou Teche region, later building a footbridge over the waterway in 1799. Breaux Bridge derives its name from Firmin's actions, and his

Breaux Bridge, as seen from the air, hugs the sleepy Bayou Teche. The town was named for a bridge spanning the bayou, built by Firmin Breaux.

daughter-in-law, Scholastique Picou Breaux, is credited with drawing up and selling lots that formed the town.

Today, a newer bridge (although still a historic one) crosses Bayou Teche at Breaux Bridge, and a statue honoring Scholastique exists at the town's City Parc, created by her great-great-granddaughter, Breaux Bridge artist Celia Guilbeau Soper (tourism.breauxbridgelive.com).

The town is world renowned for its historic downtown district and its many cafés, antique shops and restaurants, including Café des Amis, where a zydeco brunch is held every Saturday morning, complete with dancing (cafedesamis.com), and the expansive Lagniappe Antiques, with art gallery space and Buck and Johnny's Italian restaurant in a renovated auto dealership building (breauxbridgeantiques.com).

Breaux Bridge also considers itself the "Crawfish Capital of the World," celebrating the crustacean every spring with the Breaux Bridge Crawfish Festival, one of Louisiana's largest festivals.

Places to visit within a short ride include Poché's Meat Market at 3015A Main Highway, which serves up traditional Cajun sausage, meats and delectable plate

Breaux Bridge is world renowned for its historic downtown district and its many cafés, antique shops and restaurants, including Café des Amis, where a zydeco brunch is held every Saturday morning, complete with dancing.

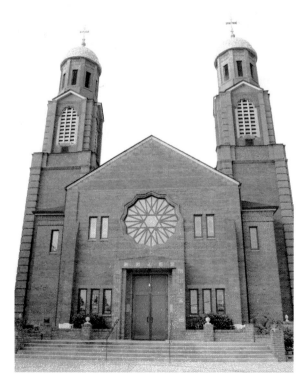

The St. Bernard Catholic Church in Breaux Bridge was established in 1847.

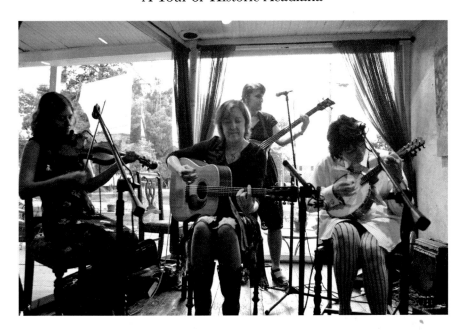

Above: The Magnolia Sisters perform at Café des Amis in Breaux Bridge. The world-famous restaurant serves up live music in addition to its fine Cajun cuisine.

Right: At Café des Amis in Breaux Bridge, famous visitors sign their names on the wall.

lunch dishes such as crawfish étouffée, stuffed pork chops and barbecue. Poché's also offers an RV park with cabins and ponds for fishing (pochesmarket.com). Cajun Palms RV Resort in nearby Henderson, a half-mile north of Interstate 10, offers three hundred deluxe RV spots, as well as twenty waterfront cabins, a pool, a clubhouse and fishing ponds (www.cajunpalms.com).

Historic dance halls that offer live Cajun music on a regular basis include La Poussiere and Mulate's of Breaux Bridge. Other places to hear live music and dance are Pat's Atchafalaya Club, part of Pat's Fisherman's Wharf Restaurant, and Whiskey River Landing in Henderson.

LAKE MARTIN

Between Breaux Bridge and Lafayette lies tranquil Lake Martin, about ten thousand acres of a naturalist wonderland, where thousands of egrets, herons, roseate spoonbills and other birds nest along the perimeter, one of the nation's largest bird rookeries. Among the cattails, lily pads and other wetland greenery, bullfrogs sing their deep-throated songs, one of the reasons Cajun call them "Ouaouarons," because in French that word mimics the

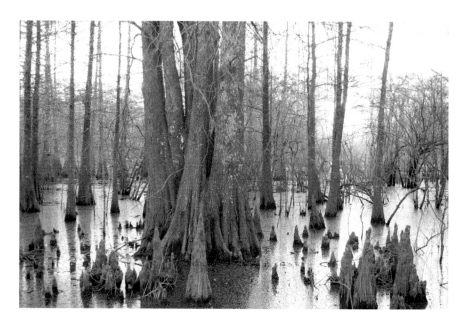

Lake Martin near Breaux Bridge is a naturalist wonderland, where thousands of egrets, herons, roseate spoonbills and other birds nest along the perimeter, one of the nation's largest bird rookeries.

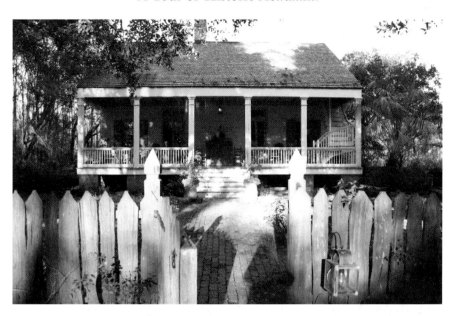

Maison Madeleine at Lake Martin is a circa 1840s restored Louisiana Creole cottage that is a bed-and-breakfast at the water's edge.

sound they make. Also swimming along the banks amid bald cypress and tupelo trees are the nutrias, turtles and alligators basking in the sun.

Thousands of bird-watchers and photographers visit the lake every year. The Nature Conservancy of Louisiana, which owns part of the property, has constructed a nature center and boardwalk that stretches out through these typical Louisiana wetlands.

Maison Madeleine at Lake Martin is a circa 1840s restored Louisiana Creole cottage, sporting walls of *bousillage* (a mud and Spanish moss mixture), antique-filled rooms, wide porches and an exterior staircase leading up to the *garconnaire*, where guests stay. In days when the French owned Louisiana, the *garconnaire* was used for boys of the house after they reached adolescence. Residents receive Cajun music as a wake-up call to a full homemade country breakfast.

ARNAUDVILLE

This artist colony north of Breaux Bridge began as an Attakapas tribal village and then was named La Jonction, due to the confluence of bayous Teche and Fuselier at the town's center. It was later renamed for the Arnauds,

a family of French settlers in the early 1800s. Today, Arnaudville is a hub of creative energy due to Arnaudville native and artist George Marks's establishment of an art center. Called the "Arnaudville Experiment," Mark's Town Market Rural Arts Centre was opened in 2005 to enhance and promote local artists, the French language, music and cultural classes through Frederick l'Ecole des Arts. The center burned down in 2010 but is on the road to being rebuilt due to enormous support from the community, while other galleries and stores have opened throughout town (arnaudvilleexperiment.homestead.com).

LEONVILLE

Free people of color settled Leonville, a rural town located along the tranquil Bayou Teche. The town was named for Father Leon Mailluchet, who built Leonville's first church in 1898. The grotto at St. Leo the Great Catholic Church at 126 Church Road in Leonville includes a walkway with the twenty mysteries of the rosary.

NEW IBERIA

Heading south down Bayou Teche from St. Martinville, visitors will find the town of New Iberia and Iberia Parish, named for the Spanish settlers who arrived in the region along with French colonists and exiled Acadians in the late 1700s. Spain owned Louisiana at the time, and the Spanish governors, worried about the English on the north side of the Mississippi River, recruited Catholics and French and Spanish citizens who would remain loyal to Spain should a conflict arise with the British. Among these were settlers from Malaga, Spain, who chose southwest Louisiana along Bayou Teche, aided by leader Francisco Bouligny, who later served as lieutenant governor of the colony.

By the late 1700s, the town was home to numerous Spanish residents but also Acadians discovering a new life, many of whom settled on the east bank of Bayou Teche, leaving the overflowing west side for pastures. After the turn of the nineteenth century, Frédéric Henry Duperier chose New Iberia after fleeing Saint-Domingue (now Haiti) during the slave revolt that left him an orphan. He and his wife, Hortense Bérard Duperier, donated land for a Catholic church and plotted lots for the incorporated town of "Iberia" in

1838. In 1847, the town was renamed New Iberia (*Nueva Iberia* means "New Spain" in English). Famous residents of New Iberia include jazz trumpeter William Gary "Bunk" Johnson and best-selling and award-winning author James Lee Burke. An African woman named Felicité was a famous resident of the nineteenth century, tirelessly administering to the sick during the city's yellow fever epidemic. She was so loved by residents of the town that when she died, every business closed shop, and the townspeople poured out for her funeral procession. Felicité is buried in St. Peter's Cemetery at 175 Ambassador West LeMelle Drive.

Today, New Iberia is considered the "Queen City of the Teche," and its quaint historic downtown won the 2005 Great American Main Street Award by the National Trust for Historic Preservation. "New Iberia has the most beautiful main street in the country," proclaimed native son and author James Lee Burke.

Walking through the downtown area is a must, with numerous historic properties within easy distance of one another. Bed-and-breakfasts are also available downtown, so a visitor could easily park at accommodations and tour the town on foot.

The most famous historic building in New Iberia is the Shadows-on-the-Teche Plantation Home and Gardens, built between 1831 and 1834 for sugar planter David Weeks. The organization offers ongoing tours of the home filled with period antiques, with docents recounting history obtained from thousands of surviving family documents. The grounds contain centuries-old live oak trees and formal gardens. The home celebrates fifty years as a National Trust Historic Site in 2011. Shadows-on-the-Teche also features several special events such as biannual arts and crafts festivals and educational workshops throughout the year (shadowsontheteche.org).

Jazz great William Gary "Bunk" Johnson lived and died in New Iberia, and he's immortalized through numerous artifacts such as his cornet, photographs and concert posters in the Iberia Parish Library Jazz Collection Room at 445 East Main Street. The Memorial Plaza on Hopkins Street is also named for the jazz trumpeter. Johnson is buried at St. Edward's Cemetery at 175 Ambassador West LeMelle Drive.

Literally next door to the library at 445 East Main Street is the Grotto of Our Lady of Lourdes built for the Christian Brothers of St. Peter's College by Architect Eugene Guillot in 1941. The grotto is patterned for the Our Lady of Lourdes Grotto in Lourdes, France, and shaded by a live oak tree believed to be about 150 years old. It was rededicated by the Veterans of

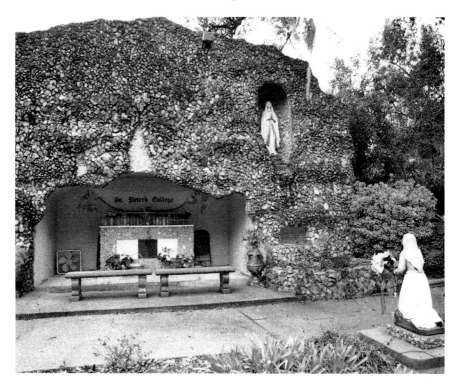

The Grotto of Our Lady of Lourdes in New Iberia was patterned after a grotto in Lourdes, France.

Foreign Wars in 1967 to honor those from New Iberia who died in the service of their country.

Heading into the heart of downtown, visitors will find two restaurants frequented by New Iberians but also by the main character of James Lee Burke's novels: private detective Dave Robicheaux. Dave loved to dine at the more upscale Clementine's Dining and Spirits (clementinedowntown.com) and the informal Victor's Cafeteria, a great place to hang with the morning crowd gathered for breakfast and good conversation (victorscafeteria.com). A guide to the historic walking tour of New Iberia, which includes historic sites too numerous to mention, is available from many retail merchants and the Iberia Parish Convention and Visitors Bureau's Welcome Center.

The Bayou Teche Museum at 131 East Main Street, dedicated to preserving and showcasing the history and culture of the Bayou Teche region, offers a wonderful starting place to learn of the region's history. The museum is located next door to the renovated Evangeline Theatre,

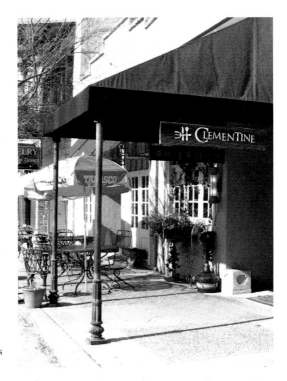

Historic downtown New Iberia includes Clementine's Dining and Spirits, a favorite spot for mystery author James Lee Burke's character, Dave Robicheaux.

once a movie house and now used for concerts and other special events (bayoutechemuseum.org).

You will need a car to drive from downtown New Iberia to the Konriko Company Store and Conrad Rice Mill, located on the grounds of the oldest operating rice mill in the United States. Visitors can tour the mill and learn about the history of the industry and the region's Acadian residents, plus shop for products in the gift store (conradricemill.com).

THE "ISLANDS"

Below Interstate 10, very little of South Louisiana rises more than a few feet above sea level, if that. But near New Iberia, several salt domes lie below the surface—thick concentrations of mineral that have survived while soil around them has eroded throughout the centuries. These salt domes appear like islands in the distance, rising upward of seventy to one hundred feet above sea level.

One of these "islands" is Avery Island, home to the McIlhenny Company, which produces Tabasco hot sauce. Edmund McIllhenny was the brainchild

behind the hot sauce, inventing this spicy concoction from *Capsicum frutescens* peppers. When people asked for more of his special sauce, McIllhenny planted a crop of peppers on Avery Island and combined them with white wine vinegar and the island's prevalent salt. Word spread, and McIllhenny patented Tabasco in 1870, naming the sauce for a Mexican-Indian word believed to mean "place where the soil is humid" or "place of the coral or oyster shell," according to the product's website. Tabasco is one of the most recognized products in the world, labeled in twenty-two languages and sold in more than 160 countries and territories.

Visitors can watch Tabasco being bottled on Avery Island and learn more about the company history, and then they can visit the Tabasco Country Store, where everything Tabasco is sold, from the famous hot sauce and its many related products to Tabasco ice cream and other innovative food products.

Avery Island's Jungle Gardens surrounding the plant and store was created by the McIlhenny family and offers acres of gorgeous landscaping, a centuries-old Buddha statue, alligators in the many waterways and "Bird City," where thousands of egrets nest. A member of the McIlhenny family,

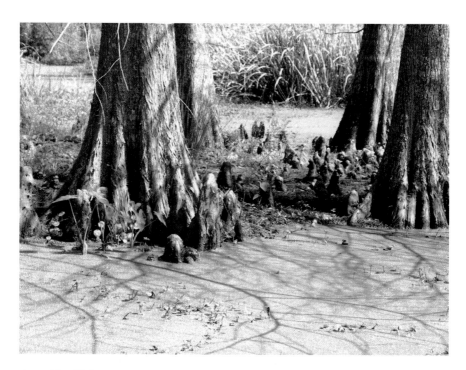

Avery Island is home to the elaborate Jungle Gardens.

E.A. McIlhenny, founded the bird colony in the 1890s in an effort to conserve the egrets, which were being hunted for ladies' hats, a fashion statement at the time (tabasco.com).

Another salt outcrop is Jefferson Island, home to Rip Van Winkle Gardens and the Joseph Jefferson Mansion (see the "Lower Prairie" chapter).

LOREAUVILLE

This sleepy village on Bayou Teche northeast of New Iberia has seen many names. It was originally called Fausse Pointe, then Dugasville for the Acadian Dugas family who settled there and then Picouville for a generous Picou family member who donated land for a chapel. The town finally became Loreauville for Ozaire Loreau of France, who settled in the area about 1840 and donated land for a Catholic church. Today, sugar cane fields cover the landscape, and most of the residents have Acadian and Creole backgrounds. Grammy Award–winning musician Clifton Chenier, "King of Zydeco," is buried at Loreauville's All Souls Cemetery (loreauville.us).

JEANERETTE

Like New Iberia, Jeanerette has its origins in Spanish settlers. But the town south of New Iberia was named for John W. Jeanerette, who arrived from South Carolina to be a tutor for one of the area plantations. Jeanerette later opened a store and post office and owned his own sugar cane plantation called Pine Grove. But that wasn't all for which he was known. Both John Jeanerette and his son, Tom, were gamblers and eventually retreated to Alabama when they ran out of money. His name was first attached to the town because John Jeanerette offered part of his home to be used as a post office. Mail came to the order of John W. Jeanerette, later just Jeanerette, and residents decided to keep it that way, despite Jeanerette's retreat into poverty and another state.

Stop by LeJeune's Bakery for some authentic French bread and other treats. The business began in 1884 and, after five generations, is still run by the LeJeune family, with the bread still baked inside 1884 ovens (lejeunesbakery.com).

The Jeanerette Museum at 500 East Main Street is housed in the Desire Guilerteau home inside the Jeanerette Bicentennial Park alongside Bayou Teche. The museum, also known as "Le Beau Petit Musée," gives a nice

history of the region's profitable sugar industry, which spans more than two hundred years in Louisiana. There's also a "Swamp Room," with various native swamp residents as specimens, vintage farm equipment and a two-seater outhouse, among other historic artifacts. Nicholas Provost, who owned a plantation in Jeanerette and is considered the founder of the town, died in 1816, and his grave site is located on the museum grounds (jeanerettemuseum.com).

Chapter 4

Upper Prairie

When the Acadians first came into Louisiana after being expelled from their homeland in Nova Scotia, they settled along the Mississippi River above New Orleans and in the bayou region near what is now St. Martinville and Lafayette. From those early days, some Acadians (Cajuns) moved west toward Texas to inhabit the wide stretches of prairie located in the southwest region of Louisiana.

I have divided the prairie region into Upper Prairie, the towns and countryside above Interstate 10, and the Lower Prairie, from Interstate 10 southward to the coast, with Lafayette as the region's "Hub City."

OPELOUSAS

Colonial settlement in Louisiana occurred as early as 1714 at Natchitoches and 1718 at New Orleans, leaving much of the southwest an open wilderness. French *coureur de bois*, or hunters and fur trappers, were thought to have visited the Opelousas region in the late seventeenth century, trading with the Opelousas who resided there, a band of the Attakapas tribe of south Louisiana. In 1720, a "poste" was established at Opelousas, almost a halfway mark between Natchitoches and New Orleans, making Opelousas the third-oldest city in Louisiana.

French soldiers began populating the poste, followed by many other nationalities, including the Acadians fleeing exile. The area was also home

to one of the largest populations of *gens de couleur libres*, or free people of color, in the nation.

"In order to encourage settlement of the newly acquired colony, Spanish Gov. Alejandro O'Reilly issued a land ordinance in 1770," wrote journalist Jim Bradshaw in the article "Blacks Came to Parish with First Europeans." He continued: "Under the terms of the ordinance, settlers could acquire liberal grants of land, particularly in the frontier areas of the Opelousas, Attakapas, and Natchitoches districts. It was during this time that many of the *gens de couleur libres* (free people of color) came to the Opelousas district from the New Orleans area."

The parish of St. Landry, when established, was known as the Imperial Parish of Louisiana and the largest in the state at that time.

Opelousas has been witness to Civil War battles, the "hidden state capital" from 1862 to 1863 during the Civil War, a variety of industries including oil and gas and cattle and the birth of Chef Paul Prudhomme, author John Ed Bradley, Louisiana governor Jacques Dupré and a host of musicians such as Hadley Castille and Clifton Chenier, the "King of Zydeco." Because

The southwestern prairies of Cajun Country range from cattle "vacheries" to sugar cane or rice fields.

of Chenier hailing from Opelousas, the town is considered the birthplace of zydeco itself. There are world-renowned zydeco dance halls located in and around Opelousas, plus every Labor Day weekend thousands descend on neighboring Plaissance to kick up the dust and dance at the Original Southwest Louisiana Zydeco Music Festival, considered the grand champion of all zydeco music events (zydeco.org). Sweet golden yams, which Louisianans call sweet potatoes, have been grown throughout the Opelousas area since the Native Americans, so naturally the town hosts a celebration in honor of this food. The annual Yambilee Festival is held every October (yambilee.com).

The best way to enjoy Opelousas and its vast and colorful history is to first stop at the Opelousas Tourist Information Center, located within *Le Vieux Village du Poste des Opelousas* (the Old Village of the Opelousas Poste), where a unique collection of historic buildings is assembled, each representing an aspect of Opelousas history. This wonderful, petite village was created in 1988 by the Opelousas Tourism and Activities Committee and is easily accessible at the east entrance of town, from Exit 19B off Interstate 49.

Le Vieux Village du Poste des Opelousas, or the Old Village of the Opelousas Poste, is a unique collection of historic buildings, each representing an aspect of Opelousas history.

Start at the Tourist Information Center, a building created to resemble an 1800s Cajun home, where helpful staff will answer questions and offer a walking tour of the property. Be sure and check out the Jim Bowie Display inside the center. The American hero known for inventing the Bowie knife and dying at the Alamo once resided in Opelousas.

Working through a large loop of the property, visitors will enjoy the African American Methodist Church built in 1948 and moved from the village of Palmetto, a community of free people of color; the circa 1911 two-room Whiteville Schoolhouse, one of the last country schoolhouses remaining in Louisiana; a country doctor's office; the mid-1800s La Chappelle House; the Andrepont Store; and a nineteenth-century outhouse. The Venus House, built about 1791 and one of the oldest Creole homes of its kind west of the Mississippi, was named for a former slave named Venus who owned the home in the early 1800s. Its walls are a great example of *bousillage*, a mixture of Spanish moss and mud. Also at the site is the Union Pacific Freight Depot, which has been restored and now houses the Louisiana Orphan Train Museum. Opelousas was one of several destinations for the orphans who were moved west from New York City by the Children's Aid Society and the New York Foundling Hospital between 1873 and 1929. The museum contains artifacts from family members and a mural by internationally known muralist and Lafayette native Robert Dafford honoring the more than two thousand children who arrived in Opelousas (laorphantrain.com).

COURTHOUSE SQUARE

The 1939 Art Deco courthouse in the center of town is the fourth courthouse to be built on the square, the first being constructed in 1806. Records contained inside hearken back to the Opelousas poste days. Gracing the outside of the building are fiberglass fiddle sculptures painted and adorned by area artists as part of a community-wide art project called "Fiddle Mania." Participating Acadiana artists include Vergie Banks, Michelle Fontenot, Christine Ledoux, Sue Boagni, June Lowry, Larry Hayes, Linda Meaux, Adrian Fulton, Gwenn Voorhies, Mary Beth Henry, Yvette Chapuis, Jerome Ford, Robbie Sebastien, Kenneth Scott, Robert Baxter and St. Landry Parish art instructors Kat Guidroz and Jerome Ford and their students (cityofopelousas.com).

On one side of the courthouse is Lawyer's Row on Bellevue Street, a group of office buildings more than one hundred years old; the circa 1911 Beaux Arts

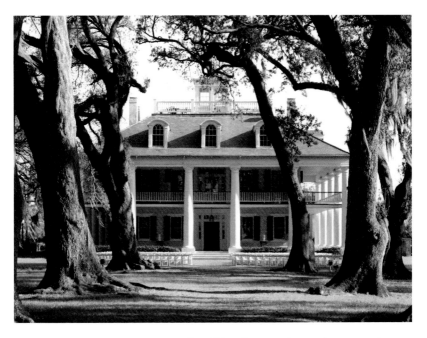

Houmas House is the grande dame of the River Road, an impressive twenty-three-room mansion with an award-winning restaurant and elaborate gardens.

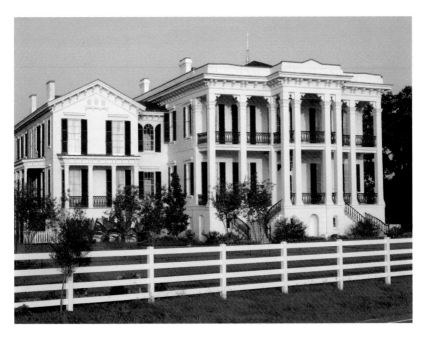

Nottoway Plantation in White Castle is considered the South's largest antebellum plantation, with sixty-four rooms.

Cajun Country in south Louisiana features a temperate climate, with plants flowering almost all year round. Summers can be brutal, but winters are mild, and spring and fall are long stretches of lovely weather.

The Jungle Gardens of Avery Island includes spectacular gardens, centuries-old live oak trees such as these and Bird City, a haven for egrets. Avery Island is home to the McIlhenny Company, which produces Tabasco.

Rip Van Winkle Gardens on Jefferson Island includes the historic Joseph Jefferson Mansion, listed on the National Register of Historic Places, and lush gardens where peacocks roam free.

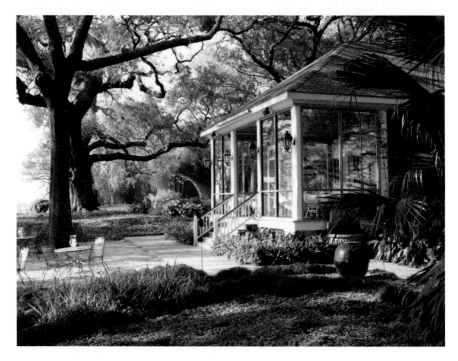

Rip Van Winkle Gardens on Jefferson Island is a favorite site of weddings for its lush gardens beside the tranquil Lake Peigneur.

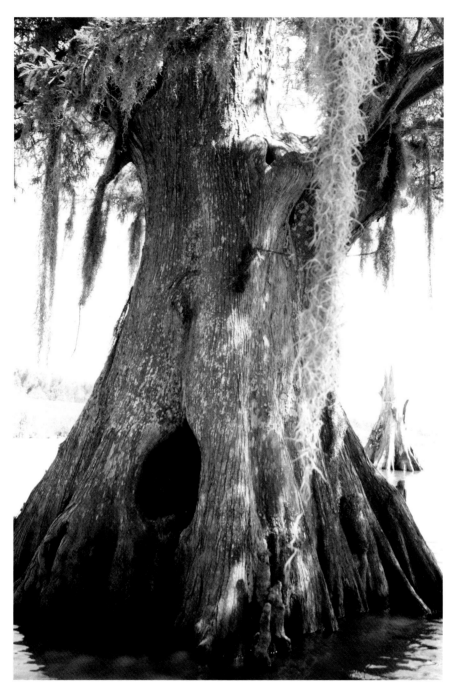

Many of the giant cypress trees growing in south Louisiana were cut down by loggers in the early part of the twentieth century. A grove of these giants remains at Lake Fausse Pointe near St. Martinville.

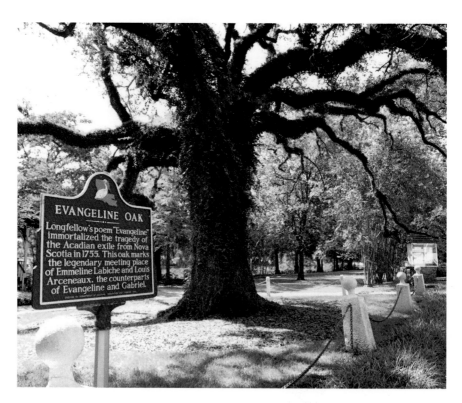

The "Evangeline Oak" in St. Martinville is the site where Evangeline supposedly waited for her Gabriel, both characters in Henry Wadsworth Longfellow's popular poem.

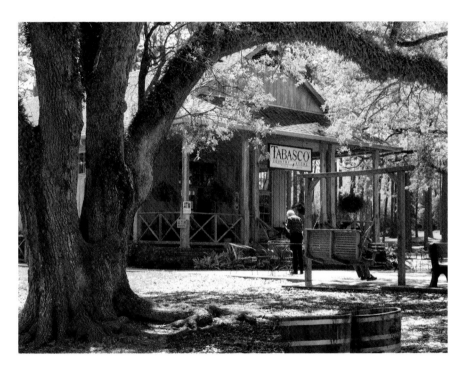

Visitors to Avery Island and the McIlhenny Company are treated to a peek inside the factory, as well as the Tabasco Country Store, where everything Tabasco is sold, from the famous hot sauce and its many related products to Tabasco ice cream.

In Cajun Country, much like in New Orleans, cemeteries include above-ground tombs because of the high water table. This cemetery exists behind St. Mary Magdalen Catholic Church in Abbeville.

Fiberglass fiddle sculptures painted and adorned by area artists as part of "Fiddle Mania" surround the 1939 Art Deco courthouse in the center of Opelousas. The courthouse is the fourth courthouse to be built on the square, the first being constructed in 1806.

Union Bank Building at the corner of Court and Bellevue Streets; the New Drug Store at 128 South Court Street, with its unique decorated tin ceiling; and the Old Federal Building at 131 South Court Street, once the home of Manon Baldwin, a free woman of color and prominent Opelousas businesswoman.

On Landry Street, the Shute Building once housed the old Star Barber Shop, where Clyde Barrow (of Bonnie and Clyde fame) was given his last haircut before being killed on the road two days later. In the next block, directly opposite the courthouse, grows the mammoth Jim Bowie Oak, estimated to be more than 350 years old and a charter member of the Live Oak Society. Next door is the Homer Mouton Law Office, constructed of handmade brick. At the corner is the oldest restaurant in Opelousas and a favorite with locals, the Palace Café.

At 120 South Market Street is the Delta Grand, an old Opelousas theater lovingly restored and used as a performance space. Back on Bellevue Street, the Old City Hall and Opelousas Town Market at 131 West Bellevue is now home to city government and parish tourism but was once the spot where area women first exercised their right to vote.

OPELOUSAS HISTORIC DISTRICT

Throughout Opelousas are numerous historic homes and businesses. One not to be missed is the Michel Prudhomme home at 1152 Prudhomme Circle (next to Opelousas General Hospital), a French Colonial home built about 1770 that's believed to be the oldest structure in St. Landry Parish. One of the country's largest camellias grows on the property.

Historic churches in Opelousas includes the impressive St. Landry Catholic Church and cemetery at 1020 North Main Street, where the first marriage of Jim Bowie was recorded; the Holy Ghost Catholic Church at 747 North Union Street, the largest Catholic congregation of African Americans in the United States; and the 1891 Mount Olive Baptist Church at 227 West Church Street, once site of the Seventh District Baptist School for African Americans. Also, the Little Zion Baptist Church at 128 North Academy is one of the oldest Baptists churches in Opelousas, founded in 1867.

For a comprehensive list of the historic structures in Opelousas, ask for the *Opelousas Historic District Walking Tour* from the city tourism center.

The St. Landry Catholic Church Cemetery in Opelousas contains graves of many of the city's pioneers.

OPELOUSAS MUSEUMS

St. Landry Parish native and folklorist Rebecca Henry created the Creole Heritage Folklife Center at 1113 West Vine Street to showcase the traditions and history of Louisiana's African American community. Henry grew up in neighboring Leonville, the daughter of a sharecropper, and she displays her family records, photographs and more to showcase the life of her parents and grandparents. Guided tours are offered weekly and by appointment. The center is included on the Louisiana African American Heritage Trail (astorylikenoother.com).

The Opelousas Museum and Interpretive Center at 315 North Main Street displays the history of the Opelousas area from prehistoric times to the present. The museum consists of a Main Exhibit Room, a Civil War Room, the Geraldine Smith Welch Doll Collection, the Opelousas Hall of Fame and the Southwest Louisiana Zydeco Music Festival Archives.

The Opelousas Museum of Art at 106 North Union Street hosts art exhibitions from private art collections and museums within the circa 1820 Joseph Richard Wier Memorial Building, an example of classic Federal architecture.

UPPER PRAIRIE DANCE HALLS

Since 1947, Slim's Y Ki-Ki has been offering fabulous live music performances, particularly zydeco bands, and attracting visitors from around the world. The popular dance hall is open on weekends and located at 8471 Highway 182 in Opelousas. The Zydeco Hall of Fame at 11154 Highway 190 just west of Opelousas also hearkens back many years, fifty and counting.

Lakeview Park outside of Eunice allows visitors a place to camp at its RV sites and cabins while enjoying live music in its massive dance hall. The park also features a lake and swimming pool (lvpark.com).

WASHINGTON

The quaint town of Washington a few miles north of Opelousas was first noted in 1770 as "Church's Landing" for the Catholic church built there, the first for the parish. Beginning in 1820, the town expanded due to steamboat traffic along Bayou Courtableau, where area farmers brought their wares to

be shipped down to New Orleans for market. Washington soon became a vital transportation hub for sugar, cotton, cattle and other products.

Many of the original historic homes, warehouses and businesses—many on the National Register of Historic Places—remain in Washington, although the bayou evolved into a sleepy waterway after the last steamboat trip left town in 1900. Today, visitors can stay in bed-and-breakfasts and shop at the many antique shops along Main Street, plus visit the circa 1938 Old Schoolhouse Antique Mall at 123 Church Street with its forty thousand-square-feet of antique shopping and 1950s café (oldschoolhouseantiquemall.com). The 1825 Camellia Cove at 211 West Hill Street and the gardens of Magnolia Ridge Plantation on Highway 103 West, built in the early 1800s, are both open to the public. The Steamboat Warehouse Restaurant occupies one of the original bayou-side warehouses, built between 1819 and 1823. Restored in 1977, the Steamboat Warehouse Restaurant serves up fine dining in a romantic setting by the bayou's edge, plus offers cottages for overnight accommodations (steamboatwarehouse.com).

GRAND COTEAU

Like Washington, Grand Coteau is a small rural town with a host of historic buildings and homes, not to mention the Academy of the Sacred Heart single-gender school for girls and St. Charles College, the first Jesuit college in the South. There are more than seventy structures designed as architecturally significant within the town's historic district, all in a variety of styles as diverse as Louisiana's history.

The Academy of the Sacred Heart opened with eight students in 1821, making it not only the oldest school in Acadiana, but also the second-oldest school in the United States west of the Mississippi. Flanked by majestic ancient live oak trees, the circa 1830 main building was made from locally made bricks and cypress and glass imported from France. Because the Academy of the Sacred Heart operates as a school for girls, tourists are not allowed to roam the property and buildings (sshcoteau.org).

The Church of St. Charles Borromeo at 174 Church Street dates back to the beginning of St. Charles Parish in 1819, the third-oldest parish in the Lafayette Diocese. Charles Smith, a wealthy planter who moved to the Grand Coteau area from Maryland, donated land for the parish, naming it St. Charles Borromeo in honor of his patron saint. A church was built on the site, but a larger one (the current structure) was constructed in 1879

The Church of St. Charles Borromeo Cemetery in Grand Coteau dates back to the early 1800s.

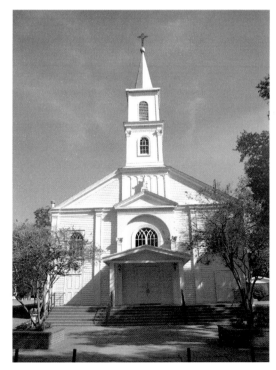

The Church of St. Charles Borromeo in Grand Coteau dates back to the beginning of St. Charles Parish in 1819, the third oldest parish in the Lafayette Diocese.

by two Jesuit brothers, Cornelius Otten of Holland and Joseph Armand Brinkhaus of Grand Coteau. The church was first named Sacred Heart in honor of the academy and its support but was later renamed St. Charles Borromeo. One of the church's most unusual architectural elements is the rear 1886 Empire-style bell tower, built to house a more than three-thousand-pound bell donated by Eleanor Millard in honor of her late husband, Dr. Millard. Other attributes include its collection of religious art and stained-glass windows. To the rear of the elegant wooden church is a vast, peaceful cemetery dating from the early 1800s (st-charles-borromeo.org).

The Jesuit Spirituality Center at St. Charles College offers personally directed retreats based on the spiritual exercises of St. Ignatius Loyola and other special workshops and events for people of all faiths (home.centurytel.net/spiritualitycenter).

SUNSET

Grand Coteau lies immediately to the east of Interstate 49, while the small town of Sunset lies just to the west, both south of Opelousas and north of Lafayette. The two villages make interesting bookends to a day's excursion, with Grand Coteau offering the historic St. Charles Parish, antique stores and the Academy of the Sacred Heart, while Sunset features eclectic thrift shops, an antique mall in two barns and several local artist galleries. Every May, Sunset hosts the Sunset Herb and Garden Festival.

Of historical note in Sunset is the 1906 town hall building, once used as the Bank of Sunset to safeguard local fortunes from silver thieves, and La Caboose Bed-and-Breakfast, where visitors can sleep in a 1904 depot, a 1920 caboose, a 1930 ticket office and a 1800 mail-passenger car among three wooded acres and gardens.

A short drive from the heart of town is Chretien Point Plantation, an elegant twelve-room home along the banks of Bayou Bourbeaux, built in 1831 by Hypolite Chretien. Privateer Jean Lafitte was rumored to have visited Chretien Point, and stories maintain that Hypolite's wife, Felecité Chretien, killed a robber on the home's staircase, a man she believed to be a pirate coming to pillage the estate. The home is now privately owned, but visitors can view the exterior and tour the grounds on the three miles of walking paths. The twenty acres that now surround Chretien Point are known to contain ghost sightings, from Civil War soldiers who died on the battle that occurred on the plantation grounds to the woman who walks the nearby wooden bridge.

LEWISBURG

Acadian exile Leandre Bourque settled in this region of St. Landry Parish, naming the town for the village that he left behind in the Maritimes of Canada. The Bourque family lost most of their land during the Civil War, but Leandre's grandson, Charles Bourque, managed to retrieve some acreage and open a store in 1892.

VILLE PLATTE

While Opelousas claims the origins of zydeco and Mamou and Eunice as the renaissance of Cajun music, Ville Platte has the official designation of being the "Swamp Pop Capital of the World," recognized as such by the Louisiana legislature for the town's "long, rich history of fostering the development of swamp pop music, as the city is the home of JIN Records, the label that has produced more swamp pop acts than any other in the state." Some of Louisiana's swamp pop greats include the Boogie Kings, Rod Bernard, Tommy McLain, Joe Barry, Jivin Gene, Johnnie Allan and Warren Storm. Swamp pop is claimed to be Louisiana's best-selling music

Ville Platte offers several murals depicting the town's history.

71

Louisiana's oldest
record shop, Floyd's
Record Shop in
Ville Platte, offers
everything from
Cajun and zydeco
to swamp pop, rock-
and-roll and country.

genre, producing hits such as "Sea of Love" by Phil Phillips of Lake Charles and "This Should Go On Forever" by Rod Bernard of Opelousas.

The more than one-hundred-year-old Elton train depot has been restored and moved to Ville Platte and now houses the Louisiana Swamp Pop Museum, operated by the City of Ville Platte. Photos, records, autographs, stage costumes and other memorabilia of the state's swamp pop history are featured here, as well as a Swamp Pop Wall of Fame (vpla.com).

Louisiana's oldest record shop, Floyd's Record Shop at 434 East Main Street, offers everything one could wish for when it comes to Louisiana music, from Cajun and zydeco to swamp pop, rock-and-roll and country. Floyd's now does a booming business by mail and online, but don't miss a chance to stop by. You never know what musician may be dropping in as well and likely cracking open his fiddle case (floydsrecordshop.com).

BUNKIE

The story goes that Bunkie was named for a monkey. Most people think that you're pulling their leg, but it's true. Captain Samuel Haas settled in Avoyelles Parish, soon becoming the largest landowner. After a trip to New Orleans, he returned home with a pet monkey for his daughter, Maccie. She mispronounced "monkey" as "bunkie," and the name caught as her nickname. It was then later transferred to the town.

The small railroad town owns a historic depot, circa 1911, once part of the Texas and Pacific Railroad. Visitors can pick up a driving tour

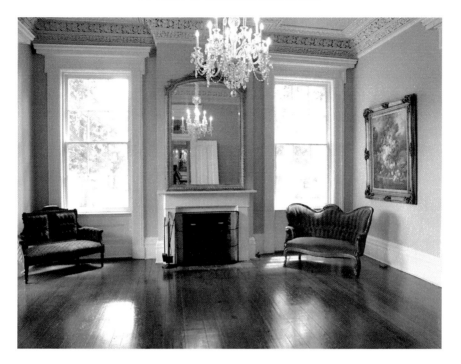

Lloyd Hall Plantation near Bunkie was built about 1820 and is on the National Register of Historic Places.

of historic homes in the area from the chamber of commerce located within. There's also several wonderful antique shops, murals on many buildings and the historic Bailey Hotel at 200 West Magnolia Street, built in 1907 and on the National Register of Historic Places (bunkie.com, baileyhotel.com).

Outside of Bunkie lies one of the loveliest plantation homes in Louisiana. Loyd Hall Plantation was built about 1820 and is on the National Register of Historic Places. The home is available for tours; a Civil War–era murder occurred here and it's rumored to be haunted, so a peek inside is a must. Loyd Hall also serves as both a bed-and-breakfast and a 640-acre working farm. Visitors can enjoy an elegant stay inside the main house or the five surrounding cottages around a pool, plus view agricultural practices, such as sugar cane production and cattle raising, typical of south Louisiana. The plantation is also available for weddings, family reunions and other special events (loydhall.com).

MARKSVILLE

Marksville may well be the northernmost point of Cajun Country, although the town is distinctly French, as in settled by those arriving from France and not by way of the Canadian Maritimes, which was the Cajun experience. Located in Avoyelles Parish and thus still within the boundaries of "Acadiana," Marksville exhibits some Cajun culture, such as Cajun cuisine in area restaurants and the *joie de vivre* attitude.

There are many wonderful historic sites to visit in Marksville and the surrounding area, including the mammoth Paragon Casino, operated by the Tunica-Biloxi tribe, and its neighboring museum that details the Tunica and Biloxi Indians who have lived on their reservation near Marksville for more than two centuries. The Tunicas covered a multistate area and moved southward due to European pressure and disease, while the Biloxis hailed from the Mississippi Gulf Coast, aligning themselves with the French and, later, Spanish. The two intermarried, although they spoke different languages (paragoncasinoresort.com). The original residents of the parish were the prehistoric Avoyel Indians, for which the parish is named. The Avoyel Indians were absorbed into the Tunica tribe.

One of the state's greatest Native American historic sites is the forty-two-acre Marksville State Commemorative Area, where a prehistoric earthwork 3,300 feet long and from 3 to 7 feet high of the Marksville culture exists, a site many archaeologists believe to be of unique national significance. Members of the Smithsonian Institute have connected Marksville to the development of the Hopewell culture of Ohio. The park overlooks the Old River, with the earthwork opening on the western and southern sides, suggesting that the mound was used for ceremonial purposes. Six other mounds are located within the main mound area, and others are built in other areas of the park (crt.state.la.us/parks/imarksvle.aspx).

In addition to the state park, Marksville has more than one hundred historical markers designating historical sites and buildings. Historic places of interest in Marksville and surrounding areas include the following.

The historic Avoyelles Parish Courthouse at 312 North Main Street in the historic downtown square is a working courthouse for the parish, but the second floor contains a concise history of both the town and the parish.

The Hypolite Borderlon House at 242 West Tunica Drive was built between 1800 and 1820, and this Louisiana Creole cottage houses a museum and tourist center showcasing the lives of early settlers of Avoyelles Parish with period antiques.

Fort DeRussy is located about four miles north of Marksville, built by slaves to defend the Red River during the Civil War. Union soldiers captured the fort during the Red River campaign of General A.J. Smith and attempted to destroy the earthen fort. Today, a large portion still exists, operated as a state historic site. Nearby is the Fort DeRussy Cemetery, a remote resting spot that some residents claim is haunted.

Visitors literally step back in time when they visit the circa 1927 Adam Ponthieu Grocery Store and Big Bend Post Office at 8554 Louisiana Highway 451 in nearby Moreauville. The quaint store contains items from decades past found in old one-room country stores, as well as the old post office located at this spot. Across the street is the 1916 Sarto Old Iron Bridge, a steel-truss swinging bridge being lovingly restored across Bayou des Glaises and a great picnic site.

EUNICE

Land developer C.C. Duson saw great opportunity in the western prairie of Louisiana, specifically a large tract of land known as Prairie Faquetaique. He purchased 160 acres and laid out plots, naming his creation Eunice after his wife, Mary Eunice Pharr Duson. He auctioned the lots in September 1894 to buyers from Louisiana, Texas, Mississippi and Alabama. As settlers arrived, so did the railroad. In time, industries such as agriculture, cattle and the railroad helped boost the town's ranks.

Today, Eunice is a hub for Cajun music and considers itself the "Prairie Cajun Capital." The Eunice location of the Jean Lafitte National Historic Park and Preserve at 250 West Park Avenue focuses on the lifestyles, music and customs of the "prairie Cajuns." Demonstrations such as weaving, cooking and quilting are routinely given, and film screenings are offered. The center also offers *Rendez-Vous des Cajuns*, a live Cajun and zydeco radio show at 6:00 p.m. every Saturday evening at the historic Liberty Theater next door, a 1924 movie house now listed on the National Register. The weekly live radio broadcast has been considered the *Grand Old Opry* of Cajun music (nps.gov/jela/prairie-acadian-cultural-center-eunice.htm).

The Cajun Music Hall of Fame and Museum at 240 South C.C. Duson Street, sponsored by the Cajun French Music Association, offers a wonderful display of early Cajun music memorabilia and artifacts, as well as honors the inductees to the Cajun Music Hall of Fame (cajunfrenchmusic.org/halloffame.html).

Next door at 220 South C.C. Duson Street is the Eunice Depot Museum, housed in the old train depot where Duson first sold plots of land in 1894. The building is listed on the National Register of Historic Places and is as fascinating as the extensive historic exhibits and town memorabilia contained within.

At the corner of North Second Street and Laurel Avenue is a mural of the Louisiana prairie by internationally known muralist and Lafayette native Robert Dafford. Located on the corner of Martin Luther King Drive and Magnolia Street is the Cajun Prairie Preservation Project, an effort to restore the original habitat of Eunice. The plot is run by the Cajun Prairie Preservation Society, an organization "dedicated to the study, preservation, restoration and education in regard to the Cajun Prairie Habitat, associated habitats and projects" (cajunprairie.org).

Savoy Music Center at 4413 Highway 190 East is owned and operated by renowned accordion maker and musician Marc Savoy, wife to equally famous musician and folklorist Ann Savoy and father to a host of musical talents. Every Saturday from 9:00 a.m. until noon, a Cajun music jam session occurs in the store, a tradition that has been ongoing since 1966. The jam session is free, but boudin and beer are always welcome. Marc Savoy's handcrafted accordions are also on display and for sale (savoymusiccenter.com).

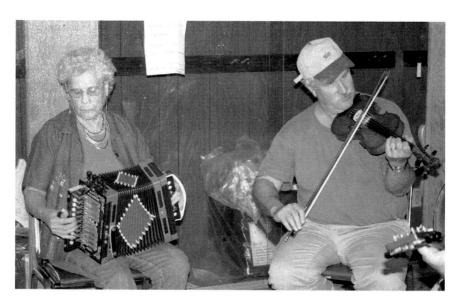

A Cajun music jam is held every Saturday morning at the Savoy Music Center in Eunice. The Saturday jam sessions have been ongoing since 1966.

Eunice is home to the local radio station KBON (101.1 FM), located at 109 South Second Street, and visitors are welcome to drop in and view its wall of fame, with the signatures and pictures of Louisiana musicians. KBON plays a variety of Louisiana music, from Cajun and swamp pop to zydeco and blues (kbon.com).

CHURCH POINT

Cajuns living today fondly remember the use of horse and buggies for transportation. Probably nowhere else in Cajun Country was this more true than in the prairie town of Church Point. Because of its buggy tradition, the town holds the Church Point Buggy Festival every June and has nicknamed itself the "Buggy Capital of the World."

Located on the banks of Bayou Plaquemine Brulee, the town was founded by Acadians in the late eighteenth century. Before the Cajuns arrived, the Attakapas and Opelousas tribes frequented the area for hunting bison and other animals feasting on the rich prairie grass. After a wide variety of settlers entered the region, a Catholic church was commissioned. Viewing the steeple rising from the flat prairie land, the area became known as *La Pointe de l'Eglise*, or Church Point (churchpoint-la.com).

Outside of Church Point in St. Edward's Catholic Church Cemetery lies the grave of young Charlene Richard, known as the "Lil' Cajun Saint" and as a purveyor of miracles. Richard died at age twelve of leukemia, but her steadfast faith and hope during her time of sickness was an inspiration to many. Since her death in 1957, many people have prayed to Richard and believe that she conducted miracles on their behalf (charlenerichard.net).

MAMOU

Mamou is located fifty miles northwest of Lafayette. The prairie village grew out of farms producing rice, cotton and corn and raising cattle and sheep. Most people recognize Mamou from its musical heritage and its annual *courir de Mardi Gras*, where costumed men and women on horseback travel the countryside to beg residents for ingredients to a gumbo.

No visit to Mamou would be complete without waking early on a Saturday morning for music and dancing at Fred's Lounge. The now world-famous lounge began its humble origins in 1946 when Alfred "Fred" Tate purchased

In the prairies of south Louisiana, crawfish and rice are grown in the same ponds but in separate seasons.

Tate's Bar and changed the name. This epicenter of Cajun culture revived the town's *courir de Mardi Gras* and created a remote AM radio show featuring the late Revon Reed as host and a variety of Cajun musicians. The bar has been credited for helping the "Cajun Renaissance" after World War II, making the world aware of south Louisiana's amazing and unique Cajun French culture.

Today, Fred's is only open from 8:00 a.m. to 2:00 p.m. on Saturdays, and visitors must arrive early to ensure a seat for the live music and radio broadcast that begins at 9:00 a.m. over KVPI in Ville Platte. Fred's Lounge has been visited by Peter Jennings, Charles Kuralt, Dennis Quaid and many other famous stars. It's not uncommon for a Mamou resident or U.S. visitor to be seated next to someone from Europe, Africa or the Caribbean (mamou.org).

CAJUN FOOD

Visitors to New Orleans expect Cajun cuisine, but the region that produces such *Cajun* culinary delights lies outside of the Big Easy, in the twenty-two parishes of south Louisiana from the Mississippi border to the Texas line. New Orleans cuisine is considered "Creole," a mixture of the cultures that settled into the city, most notably European (French and Spanish), African, Caribbean, Native American and other American influences that arrived after the Louisiana Purchase in 1803. Cajun cuisine is considered, well, Cajun!

Although both cuisines derive from French roots, and many of the cultures and influences of New Orleans infiltrated Cajun culture as well, the two developed as distinct individual cuisines. Creole cuisine has a more sophisticated design and may be served in several courses, while Cajun leans more to the country way of cooking, smothered meats over rice and meals such as jambalaya cooked in one pot.

In a nutshell, "Creole is to the city as Cajun is to the bayou countryside," writes Kit Wohl in *Arnaud's Restaurant Cookbook.*

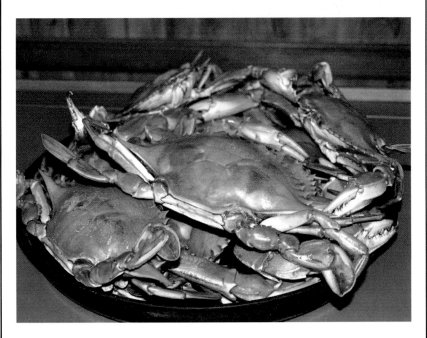

Blue crabs are prevalent in south Louisiana's brackish waters. Residents boil them with spices and serve them up hot.

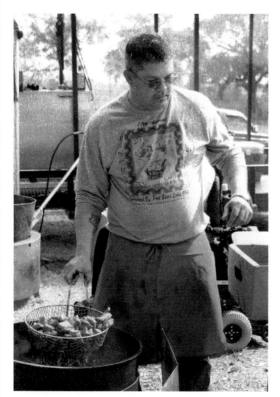

Above: Cajun spices are popular in Louisiana, and natives always have their favorites.

Left: Festival participants cook up cracklins at La Grande Boucherie des Cajuns in St. Martinville, held around Mardi Gras.

Both include European traditions, such as starting with a roux (mix of flour and oil cooked on a low heat) and the "holy trinity" of onions, celery and green peppers. During Spain's occupation of Louisiana, elements such as rice, spices and tomatoes were incorporated (although tomatoes are used mostly in Creole cooking). But the spices are derived from the flavors added to food while cooking—and maybe a little Creole seasoning and hot sauce.

Throwing pepper and hot sauce onto any type of food and calling it "Cajun" does not make it so. Visitors to Cajun Country who sample authentic Cajun cuisine will discover what makes our cooking world famous, and it's not an overabundance of heat. That wonderful spice is derived from cooking with flavor.

In addition to loving to cook and eat, Cajuns love a good festival, especially with good music and dancing. A good example is La Grande Boucherie des Cajuns, now a festival but once a communal butchering of a hog. Called a "boucherie," the occasion brought together family members and neighbors, all of whom would participate and leave with some byproducts of the butchering, including pork, sausage, boudin and cracklins. Cajuns from St. Martinville gather to celebrate the annual La Grande Boucherie des Cajuns around Mardi Gras, holding crackling-cooking contests, serving up freshly made Cajun dishes and dancing to live music.

Chapter 5
Lafayette

In the early days of the colony, few Louisiana settlers ventured west of the Mississippi, despite the lure of vast prairies for crops and bayous and wetlands teeming with wildlife. Spain owned what is now Texas and was not receptive to the French colonists invading their region, and the Native Americans of the southwest regions were thought to be cannibalistic, although that has never been proven.

A few settlers headed west to what is now the Lafayette area, but European settlement occurred on a large scale when Spain took possession of Louisiana and welcomed the Acadians into the colony. Many found the Vermilion River appealing, with its access to trading, and farms sprouted up along its banks.

In 1821, prominent landowner Jean Mouton donated land for a church, one that would be named for his patron saint. St. John's Cathedral rises today from the spot where the original church was built, having been through a few incarnations, including being occupied during the Civil War. About the same time that Mouton offered land for a chapel, the Catholic Church created a parish for the region extending from Mouton's plantation to the Gulf of Mexico and west to the Sabine River, Louisiana's border with what was to become Texas. This new parish was named for the American Revolutionary hero, the Marquis de Lafayette.

Mouton later donated land for the parish courthouse and named the town Vermilionville, but in 1884 when the town's charter was revised, both the town and the parish became known as "Lafayette."

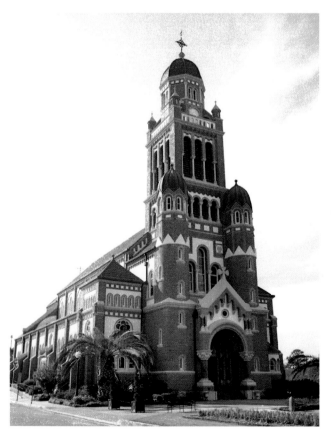

Above: This sign in Lafayette recognizes the 250 years the Acadians have been in Louisiana.

Left: The Cathedral of St. John the Evangelist Catholic Church in Lafayette was built on land donated by Lafayette founder Jean Mouton. The church also offers a museum, which explains the parish's varied history.

In 1898, Lafayette competed with other Louisiana towns to become the site for the Southwestern Louisiana Industrial Institute (SLII), with the Girard family of Lafayette offering up twenty-five acres of land and the town $18,000 with a property tax supplement. Lafayette won the new university, and classes began in September 1901. State senator Robert Martin authored the bill that created SLII, and the oldest building on campus, Martin Hall, is named in his honor. In 1921, the school was renamed Southwestern Louisiana Institute and then, in 1960, the University of Southwestern Louisiana. Today, the school lives under yet another name, the University of Louisiana at Lafayette.

For years Lafayette existed as a hub for farms throughout the southwest portion of the state, with waterways such as the Vermilion River and the nearby Atchafalaya Basin serving as thoroughfares to New Orleans, Galveston and Houston. The town attracted students to the university and the sick to regional hospitals. In 1950, one of the town's prominent businessmen, Maurice Heymann, created the Heymann Oil Center as yet another hub, one for the growing oil and gas industries. That one development helped lure oil and gas companies into the Lafayette area, creating a boom to the local economy. The "Hub City" has been prospering and growing ever since.

HISTORIC DOWNTOWN

Off Interstates 10 and 49 and away from some of the more bustling thoroughfares lies the heart of Lafayette, a few blocks full of historical and governmental buildings, tree-lined streets, museums and great dining and nightlife that make up downtown. It's also where the immensely popular Festival International de Louisiane happens the last weekend in April, with free live music on several downtown stages, not to mention arts and crafts, food and special events. Festival International is the largest free Francophone festival in North America and consists of more than one hundred live performances over five days (festivalinternational.com). In the summer, the Acadiana Symphony Orchestra serenades residents for the Fourth of July outdoor concert in the town's Parc International (acadianasymphony.org); in the spring and fall it's Downtown Alive!, Bach Lunch and Movies in the Parc. The second Saturday of every month is the popular ArtWalk, collected gallery openings with live music, food and more throughout downtown (lafayettedowntown.org).

Take a walking tour through downtown Lafayette and you'll find Cajun history on the sides of buildings. Award-winning mural artist Robert Dafford, one of the most celebrated muralists in America today, has created several

Award-winning mural artist Robert Dafford, one of the most celebrated muralists in America today, has created several mammoth pieces of outdoor artwork throughout Acadiana, including Lafayette's *Flying Violin*, painted in 1988 as the first in a series connecting Lafayette and its Cajun culture to Canada, France and Belgium.

mammoth pieces of outdoor artwork, including the *Flying Violin*, painted in 1988 as the first in a series connecting Lafayette and its Cajun culture to Canada, France and Belgium. Alongside a downtown building, which used to be a parking garage, is a 125-foot-tall painting of a 1950s-era car with the reflection of local musicians performing in the hub cap. A horizontal mural titled *Till All That's Left Is a Post Card* livens up a 100-foot-wide stretch of building depicting the nearby Atchafalaya Basin and the problem of the disappearing wetlands. One mural explores the history of Louisiana and Canada, both instrumental in the formation of our region, and its placement serves as a fabulous backdrop for one of the many stages of Festival International.

The Lafayette Museum–Mouton House at 1122 Lafayette Street was the "Sunday house" to Lafayette founder Jean Mouton, a place to rest while visiting town on Sundays. Built about 1800 and one of Lafayette's oldest houses, the site now offers a history of both the Moutons and the city as the Lafayette Museum. Naturally, the home on the National Register of Historic

A Tour of Historic Acadiana

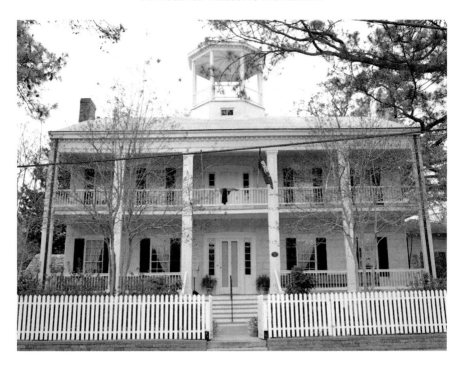

The Mouton House was the "Sunday house" to Lafayette founder Jean Mouton and now houses the Lafayette Museum.

Places is full of antiques and history, from Native Americans to the Civil War, but visitors can get a glimpse into the Mouton family, as well. Jean Mouton's son, Alexandre Mouton, was the first democratic governor of Louisiana, and his grandson, Jean Jacques Alfred Mouton, graduated from West Point and rose to rank of brigadier general in the Confederate army, leading his Louisiana troops in successful battles throughout south and central Louisiana until he was shot and killed at the Battle of Mansfield. At the Mansfield State Historic Site in northeast Louisiana, there is a marker honoring Mouton, but his statue also graces the Lafayette City Hall downtown.

The Cathedral of St. John the Evangelist Catholic Church at 914 St. John Street appears regally above the skyline, a Dutch Romanesque church completed in 1916 on the site of the city's original church, built in 1821. On the National Register, the property also includes an above-ground cemetery, with graves dating back to 1820 and members of the Mouton family being buried here. Next to the cathedral grows a live oak tree believed to be close to five hundred years old! The tree is enclosed with a wrought-iron gate to protect its massive branches (the tree stretches 210 feet across) and root

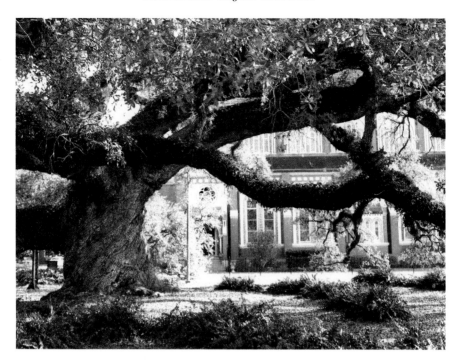

Next to the Cathedral of St. John the Evangelist Catholic Church in Lafayette grows a live oak tree believed to be close to five hundred years old.

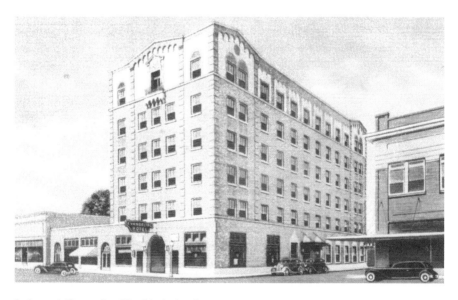

Lafayette's Evangeline Hotel in its heyday.

system. The church also offers a museum that explains the parish's varied history (saintjohncathedral.org).

Old stores serving the downtown area include the old Heymann Food Center building at 201 East Congress Street, now the Children's Museum of Acadiana; Heymann's Department Store, now the Lafayette Science Museum at 433 Jefferson Street; the Old Guaranty Bank Building at the corner of Jefferson and Congress Streets, now the Jefferson Street Pub; the former Lafayette Hardware Store at the corner of Vermilion and Buchanan Streets, built about 1890, now an architectural firm office; and its neighboring First National Bank Building at Jefferson and Vermilion, part of which remains but has been incorporated into the Acadiana Center for the Arts, which includes a gallery space inside the old bank vault.

The tale of Evangeline was told in murals within the Evangeline Hotel at 302 Jefferson Street, built in 1932, and was the site of the city's first radio station. The hotel fell into disuse until it was renovated in 1995 as a senior citizens apartment complex. To the rear at Third and Vine Streets is Cité des Arts, a multiuse cultural center housed in an Art Deco former bus station.

The lovely San Souci Gallery at 219 East Vermilion Street has lived through many incarnations: the Lafayette Post Office, an antique store, an inn, retail shops such as a shoe repair and saddle shop and the San Souci Book Store, operated by Edith Garland Dupre, a former professor of the University of Southwestern Louisiana (now the University of

San Souci Gallery has been a Lafayette post office, an antique store, an inn, retail shops such as a shoe repair and saddle shop and the San Souci Book Store. Today the all-cypress circa 1885 building houses work by dozens of artisans of the Louisiana Craft Guild and was voted one of the top sixteen places to shop in the South by *Southern Living* magazine.

Louisiana–Lafayette) and namesake of the college's library. Today the all-cypress building circa 1885 houses work by dozens of artisans of the Louisiana Craft Guild and was voted one of the top sixteen places to shop in the South by *Southern Living* magazine. The name means "without care" (louisianacrafts.org).

Across from San Souci Gallery is a row of businesses within the newly renovated Tribune Print Shop complex at 210 East Vermilion Street. The building contains the elegant French Press restaurant, Philippe's Wine Cellars and Recycled Cycles bicycle shop. Next door is Trynd Restaurant at 116 East Vermilion Street, site of the former Hope Lodge No. 145, built in 1916. The lot was originally donated to the Hope Lodge by Louisiana governor Alexander Mouton, a lodge member.

The original Lafayette City Hall was constructed by the Works Progress Administration in 1939 and used for municipal purposes until 1989. Today, the building houses the Downtown Development District (which offers a great walking brochure of downtown) and Festival International de Louisiane. Standing guard out front is General Jean Jacques Alfred Mouton, the grandson of the city's founder and a Civil War hero.

It might seem odd to consider an ice cream parlor historical, but the Borden's free-standing parlor at Jefferson Street and Johnston is the last Borden's store of its kind in existence. Built in 1940, the ice cream parlor was a hit among university students, serving up milkshakes, malts and ice cream cones. Next door on 215 East Convent Street is the Blue Moon Saloon and Guest House, both a great live music venue and a hostel. Many bands from Lafayette's booming music scene have recorded albums here (bluemoonpresents.com). Another great place to dance is El Sido's Zydeco and Blues Club on St. Antoine Street, just north of downtown.

THE UNIVERSITY OF LOUISIANA AT LAFAYETTE

The University of Louisiana at Lafayette has evolved continuously, from its beginnings as the Southwestern Louisiana Industrial Institute in 1901 to the acclaimed and multifaceted university today. The first president was Dr. Edwin Lewis Stephens, who planted live oak trees along Johnston Street and University Avenue, gracious trees laced with Spanish moss (and a few Mardi Gras beads) that remain today. Stephens later founded the national Live Oak Society, which lists the trees themselves as members, those one hundred years old and above.

The BeauSoleil House of Lafayette, open to the public to tour, is a technological hybrid house that's completely sustainable. It won the Market Viability and People's Choice Awards at the 2009 Solar Decathlon.

Many of the original buildings exist on campus, plus a few constructed by the Public Works Commission under President Franklin D. Roosevelt, great examples of Depression-era architecture. In the middle of the campus is Cypress Lake, a swampy body of water that actually contains alligators, albeit small ones that are not considered dangerous.

The BeauSoleil House is more of a structure that will become historical in time. The sustainable building was created by university students to compete in the U.S. Department of 2009 Energy Solar Decathlon competition in Washington, D.C., a worldwide competition in which twenty colleges and universities were chosen to design, build and operate the most attractive and energy-efficient solar-powered home. The ULL students named their creation BeauSoleil, which means "Beautiful Sun" in French or "Sunshine" in Cajun French. Joseph "BeauSoleil" Broussard was also a local Cajun hero (and namesake to the popular Cajun band BeauSoleil), so the title was especially appropriate. The technological hybrid house that's completely sustainable won the Market Viability

Girard Park was named for the Girard family, who donated land to be used for Southwestern Louisiana Industrial Institute, now the University of Louisiana at Lafayette. The expansive park offers a wide variety of recreational spaces, pond and hiking trails, plus it is the site of Festivals Acadiens et Creole every fall.

and People's Choice Award and is now open to the public, just outside Fletcher Hall. The building includes rooftop solar cells that generate more energy than the house consumes, a "dog trot" transitional space, water-collecting cistern, operable shutters that provide both shade and hurricane protection for windows, state-of-the-art kitchen and native products throughout the home.

The BeauSoleil House overlooks Girard Park, named for the family who donated land to be used for the university. The expansive park offers a wide variety of recreational spaces, pond and hiking trails, plus it is the site of Festivals Acadiens et Creole every fall.

The Paul and Lulu University Art Museum at 710 East St. Mary Street is one of Lafayette's most outstanding modern architectural gems, situated on the outskirts of Girard Park but part of the University of Louisiana campus. It's wall of sea-green glass reflects its neighbor, the 1967 original university Art Center, designed by noted Louisiana architect A. Hays Town

The Paul and Lulu University Art Museum is one of Lafayette's most outstanding modern architectural gems, situated on the outskirts of Girard Park but part of the University of Louisiana at Lafayette campus.

and patterned after the 1812 Hermitage Plantation in Darrow, Louisiana. The Greek Revival building is surrounded by twenty-four Doric columns (museum.louisiana.edu).

CAFÉ VERMILIONVILLE

This historic building at 1304 Pinhook Road was built about 1818 and served as Lafayette's first inn. Today, fine Cajun and Creole dining is on the menu here as Café Vermilionville. The walls contain early Louisiana insulation of Spanish moss and mud known as *bousillage*, and other features include massive cypress beams and floorboards, fireplaces and a patio garden that's visible from one of the dining rooms. Federal troops occupied the building during the Civil War, and evidence of battles has been found on the property.

ACADIAN VILLAGE

Acadian Village is a re-creation of a typical Cajun village, offering visitors an insider's glimpse into the homes, businesses and churches of early Cajun life in south Louisiana. The buildings were brought to the property—owned by the Lafayette Association for Retarded Citizens—in an effort to increase area tourism and provide a revenue stream for the association. Most of the nineteenth-century properties were donated by families and are named for the ancestors who lived in them. Properties include the Bernard House, built about 1800 in nearby St. Martinville, a good example of the use of *bousillage entre poteaux* (mud between posts) construction; the Billeaud House, built before the Civil War and used at the Billeaud Sugar Plantation; and the LeBlanc House, built in 1828 and the birthplace of Dudley J. LeBlanc, a Louisiana state senator, a dedicated preserver of the Cajun culture and the self-promoting creator of Hadacol, a popular vitamin tonic with a touch of alcohol.

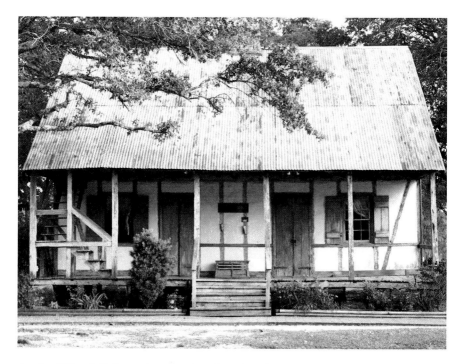

Acadian Village in Lafayette is a recreation of a typical Cajun village, offering visitors an insider's glimpse into the homes, businesses and churches of early Cajun life in south Louisiana.

For Cajun boudin balls, you take the mixture used for boudin sausage, roll it into balls and then bread and fry them. Both boudin sausage and boudin balls are popular among natives of Cajun Country.

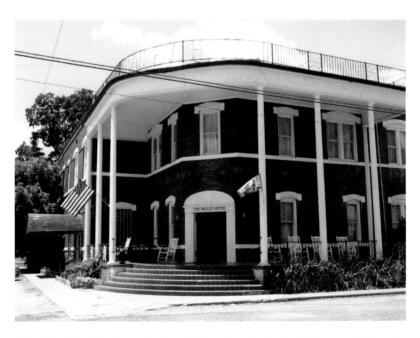

The Bailey Hotel in Bunkie, built in 1907 and on the National Register of Historic Places, was the place to stay while traveling through Avoyelles Parish.

The "holy trinity" in Cajun cuisine—the basis of most dishes and a good source of spice—consists of onions, green peppers and celery.

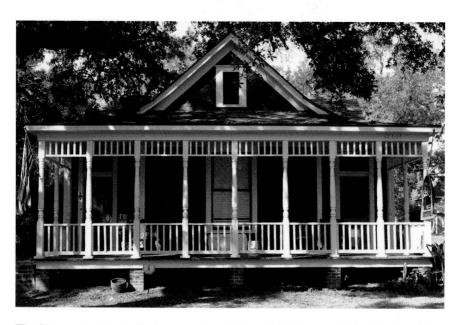

The Charpentier historic district covers forty blocks within downtown Lake Charles, with homes dating back to the 1800s and early 1900s. The district's name reflects the individual styles of the carpenters, or *charpentiers* in French.

Delcambre is a small Cajun town located south of Lafayette, but it produces some of the largest shrimp in the world. These jumbo Gulf beauties were bought fresh off the streets of Delcambre.

The Cajun Music Hall of Fame and Museum in Eunice, sponsored by the Cajun French Music Association, offers a vast display of early Cajun music memorabilia and artifacts, as well as honors the inductees to the Cajun Music Hall of Fame.

The annual Festivals Acadien et Créole in Lafayette occurs every October and features numerous Cajun and zydeco bands, as well as arts and crafts, cultural workshops and plenty of great Cajun food.

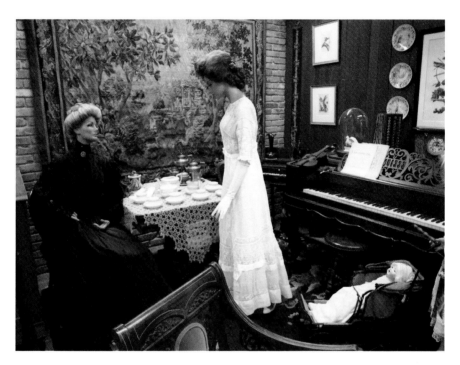

A great place to learn about Lake Charles history is the Imperial Calcasieu Museum. The museum showcases life in the nineteenth and early twentieth centuries and displays Native American artifacts, an old pharmacy and a letter of marque given from King Louis XVI of France to a local pirate.

In Lafayette, street signs are bilingual to promote the area's French heritage.

Jean Jacques Alfred Mouton was brigadier general in the Confederate army, leading his Louisiana troops in successful battles throughout south and central Louisiana until he was shot and killed at the Battle of Mansfield. The grandson of Lafayette founder Jean Mouton, Alfred Mouton's statue graces the front of the original Lafayette City Hall constructed by the Works Progress Administration in 1939.

Left: Fiberglass fiddle sculptures painted and adorned by area artists grace the perimeter of the Opelousas Courthouse, part of a community-wide art project called "Fiddle Mania."

Below: Ville Platte, one of the northernmost cities of Louisiana's Cajun Country, offers several murals depicting the town's history. Ville Platte is considered to be the "Swamp Pop Capital of the World."

Dudley J. LeBlanc, a Louisiana state senator and creator of the vitamin tonic Hadacol, was also a great supporter of Cajun culture. Here he is at the White House with a group of "Evangeline Girls" and President Herbert Hoover.

A sleepy bayou runs through the town, filled with ducks and other wildlife, plus there is a large pavilion for special events, including the always popular Noel Acadian au Village event at Christmas. Acadian Village is also a great backdrop for photo shoots and a popular wedding destination.

VERMILIONVILLE

Another collection of historic structures forming a village is Vermilionville, the Cajun and Creole Folklife and Heritage Park that represents the lifestyle of Acadian settlers from 1765 to 1890 and named for Lafayette's original title, Vermilionville. In addition to the eighteen buildings on site, there are natives speaking Cajun and Creole French in period costume while making age-old crafts, music in the pavilion that's big enough for everyone to dance in and La Cuisine de Maman (Mama's Kitchen) restaurant, which serves up traditional Cajun and Creole dishes. Vermilionville also sponsors special events throughout the year, such as the Earth Day celebration, mock Cajun

weddings, Creole Culture Day and a traditional Cajun Mardi Gras. The Bayou Vermilion District, the site's parent organization, also offers canoe trips and guided boat rides up the neighboring Vermilion River.

JEAN LAFITTE NATIONAL HISTORIC PARK AND PRESERVE

The Jean Lafitte National Historic Park and Preserve offers several sites throughout south Louisiana, including the French Quarter, the Barataria Preserve (where privateer Jean Lafitte smuggled goods into the state) and the Chalmette Battlefield and National Cemetery in Chalmette, where the Battle of New Orleans occurred. Throughout Cajun Country, the park offers the Wetlands Acadian Cultural Center in Thibodaux, the Prairie Acadian Cultural Center in Eunice and the Acadian Cultural Center in Lafayette. All three showcase the traditions of the Acadians (Cajuns) with exhibits on settlement patterns, history, music, Mardi Gras, dancing, food, crafts such as weaving and industry such as wooden boat building.

The Acadian Cultural Center in Lafayette, located next to Vermilionville, is the best place to start when traveling through Cajun Country, offering the history of the Acadian people who regrouped among the bayous, swamps and prairies of south Louisiana. Visitors can view an educational film about their early life in Canada and their diaspora that sent the Acadians throughout the American colonies, England, the Caribbean and France. Exhibits in the center also spotlight the contemporary culture of Cajuns, their wonderful food, music, storytelling and even the tradition of telling jokes. In addition, there are special ranger-led talks and boat tours on the nearby Vermilion Bayou and summer camps for kids, among other special events.

AHHH T-FRERE'S BED-AND-BREAKFAST

The Comeaux home, built in 1880, has four bedrooms in the main house and two more guest rooms in the *garconniare*, a separate building once used to house pubescent teenage boys. Guests have use of the bed-and-breakfast's parlor, enclosed porch and garden gazebo, plus may enjoy after-dinner drinks and Cajun canapés on the gallery, wake-up coffee in their rooms and a Cajun breakfast. T-Frere's is named for Oneziphore "Ti Frere" (meaning "little brother") Comeaux. Guests who have stayed at the bed-and-

This page: T-Frere's Bed-and-Breakfast was built in 1880 for Oneziphore "Ti Frere" Comeaux. It is believed to be haunted by Oneziphore's sister, Amelie.

breakfast, including the owners, have reported ghost sightings and unusual happenings and are more than happy to share. Most believe the ghost to be Amelie Comeaux, who moved in with her brother, Oneziphore, after losing her husband and child at an early age. She taught math to Lafayette schoolchildren but was stricken with a fever and fell into the well. Most of the sightings have been of "a little lady" who speaks only French and who wears her hair parted down the center and back in a bun.

The Cajun hospitality, whether by the living or the ghost who haunts there, is top notch, which is why AHHH T-Frere's was voted the "Best Bed and Breakfast in the South" in 2010 by *Southern Traveler AAA* magazine (tfreres.com).

CARENCRO

The town of Carencro lies north of Lafayette and was settled primarily by Acadians beginning in 1765. The town derives its name from an Attakapas Indian legend stating that carrion crows feasted on the bones of a mastodon many years before. Another story claims that the town was named for a buzzard sporting a red head. Either story signifies a carrion-type bird, but what visitors will find now is a quaint town with many Victorian homes and St. Peter's Roman Catholic Church, with its more than one hundred pews sporting coats of arms on the ends, carved in the late 1960s from red gum wood by Ludwig Kienenger, a Bavarian woodcarver living near Dallas, Texas (sprcc.org).

SCOTT

The Southern Pacific Railroad gave birth to this small town on the outskirts of Lafayette in 1880, naming it after railroad superintendent J.B. Scott. Railroad timetables listed Scott as the "origin of western travel," and the town's slogan has been "Where the West Begins" ever since. Visitors along Interstate 10 can exit at Scott and immediately find La Maison de Begnaud, Scott's Welcome Heritage Interpretive Center, a historic home that's been renovated into a tourism information and civic community center.

Close by are several wonderful places to sample the unique Cajun boudin sausage, among other culinary specialties, such as Best Stop (beststopinscott. com) and Early's Food Store (a local favorite for fried turkeys). The Coffee

Depot at 902 St. Mary Street is the newcomer to town, a delightful breakfast and lunch spot and coffee shop housed in a renovated feed store. Visitors may also view the art of Floyd Sonnier at his Beau Cajun Art Gallery, the old Scott Pharmacy and Bourque's Social Club housed in a circa 1902 building, all in the 1000 block of St. Mary Street (cityofscott.org).

YOUNGSVILLE AND BROUSSARD

Both towns serve as bedroom communities to Lafayette, with historic homes and buildings at their heart and modern subdivisions flanking the perimeter of their downtowns.

Broussard, named for merchant Valsin Broussard, a descendant of Joseph "Beausoleil" Broussard, an Acadian hero, lists fourteen properties on the National Register of Historic Places, some doubling as bed-and-breakfast establishments. The original name of the town six miles south of Lafayette was Cote Gelee ("frozen hills"), possibly pertaining to the slight hills of the area during the particularly cold winter of 1784. Like Lafayette and surrounding areas, Europeans visited the Broussard area as trappers and hunters, but real settlement occurred when Acadians arrived from exile in the middle of the eighteenth century.

Among the first Acadians to arrive were brothers Joseph and Alexandre Broussard, both nicknamed "Beausoleil" for their smiles and easy attitudes. Joseph Broussard became captain of the militia and commandant of the Acadians in the Attakapas country before his early death in 1765. Joseph Broussard is honored with a monument in front of the Broussard City Hall (broussardla.com).

Chapter 6

Lower Prairie

Much of the area south of Interstate 10 contains both bayous and marshlands, as well as wide-open stretches of prairie. Here sugar cane grows along with the alternating crops of rice and crawfish in contained ponds. Flocks of birds arrive every spring and fall in the migratory patterns of the Mississippi Flyway.

Perhaps the largest population of Cajun French speakers live in Vermilion Parish just south of Lafayette—according to the 1990 Census of Louisiana. But like every other parish in Cajun Country, the region also contains a host of other ethnicities, such as German, French, Swiss and African, providing this southern prairie with a gumbo of culture.

MAURICE

Maurice is situated within a short drive from Lafayette, making it an ideal bedroom community of the larger city. Named for Dr. Lastie Maurice Villien of France, the town is home to Hebert's Meat Market and the "Turducken," a funny name for a turkey stuffed with boneless chicken and duck with cornbread dressing and pork stuffing separating each poultry piece. Of course it's well seasoned the Cajun way. There's argument over who originated the turducken, but Hebert's lays claim to its inception. *National Geographic* had an article on the town and its famous dish, attributing the turducken to brothers Sammy and Junior Hebert and their Maurice family meat market. Hebert's

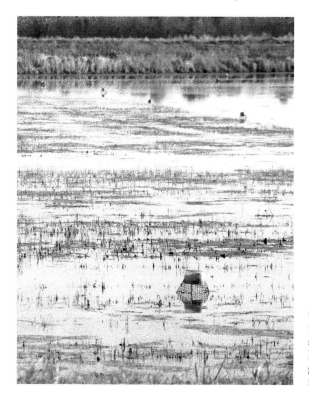

Crawfish ponds are numerous throughout the south Louisiana prairie. Many farmers alternate the growing of rice with the raising of crawfish.

sells more than ten thousand turduckens in their stores that include three in Houston and one in Tulsa, Oklahoma.

In 1934, four African American priests arrived in Lafayette to operate separate Catholic church parishes for the region's black residents. The Lafayette-area parish soon grew to more than two thousand by 1941, and property on West Pont de Mouton Road was purchased and a small chapel built. By 2009, the chapel fell into disarray, but the Woodlawn Players of Maurice purchased the building and moved it to property in Maurice along the Vermilion River. The chapel is scheduled to become part of the Woodlawn Road Arts District and used for local performances, religious services and theatrical productions (woodlawn-chapel.com/wordpress/?p=1).

Maurice is also home to Vivian Alexander, who makes unique enamel evening purses in the style of Fabergé. Today, Vivian Alexander purses—as well as art objects, Easter eggs and other fine enamel gifts—are found in famous households throughout America and in numerous films. Visitors may tour the factory by appointment (vivianalexander.com).

ABBEVILLE

Reverend Pére Antoine Désiré Mégret of France was sent to Vermilionville, now called Lafayette, to serve as pastor of St. John's Parish, but he inherited more than he bargained for. A group of arrogant church members known as the "marguilliers" ran the show, causing a major division within the church. Mégret would hear none of it, informed the marguilliers that his boss was the bishop, not them, and was attacked on the street as a result. Mégret closed the church in retaliation and, on July 25, 1843, purchased land along the Vermilion River in Vermilion Parish from Joseph LeBlanc for a church, rectory and cemetery. The cost was $900. When Mégret refused to perform Mass in Lafayette, the church members took a stand and elected new leaders. Mégret then began traveling to St. Mary Magdalen Catholic Church in Abbeville, dedicated in 1844, while leading the parish of Lafayette's St. John.

The town of Abbeville may be grateful for the fight in Lafayette since land not used by the rectory was sold as town lots. Originally called La Chapelle for Mégret's church, in 1844 the name was changed to Abbeville, presumed by historians to be for Father Mégret's hometown of Abbeville, France. Father Mégret also donated land to a courthouse and arranged for the city to have two centralized squares.

Mégret died administering to the yellow fever victims of 1853 and was buried in Abbeville but was later entombed within St. John's Cathedral in Lafayette. St. Mary Magdalen Catholic Church was destroyed by fire but replaced by the current structure in 1911.

Honoring its French origins, Abbeville is the site of the annual Giant Omelette Celebration in which thousands of eggs—and dashes of Tabasco, of course—are used to make an oversized omelette in historic Magadalen Square (giantomelette.org).

Historic sites to visit in Abbeville include Magdalen Square, where the 1911 Romanesque Revival St. Mary Magdalen Catholic Church exists today, fronting the historic cemetery (dating back to 1843) in which many of the town's pioneers are buried. The church rectory neighboring both is rumored to be haunted. The actual square is a gathering place for the town and includes a gazebo, a statue of Father Mégret and a historical marker explaining the origins of Abbeville. The Abbeville Cultural and Historical Alliance Center Museum and Art Gallery at 200 North Magdalen Square combines the efforts of four community organizations with the purpose of displaying art exhibits, documenting genealogy and running the Giant Omelette Celebration (abbevillemuseum.org).

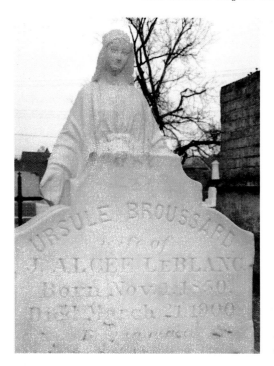

St. Mary Magdalen Catholic
Church Cemetery in Abbeville
dates back to 1843.

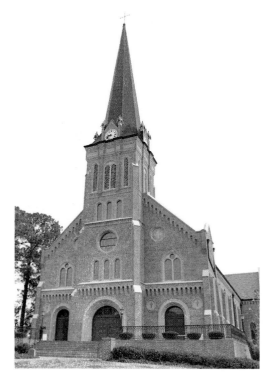

St. Mary Magdalen Catholic
Church in Abbeville was dedicated
in 1844 but was later destroyed by
fire. The current structure was built
in 1911.

Right: Reverend Pére Antoine Désiré Mégret of France is considered the father of Abbeville, for he built a church here in 1844 and then sold unused plots of land as town lots and developed the town's two centralized squares.

Below: Abbeville is home to the C.S. Steen Syrup Mill, which produces Steen's cane syrup.

The Abbeville City Hall at 101 North State Street, once serving as the town's hotel, and the Vermilion Parish Courthouse at 100 North State Street are both interesting government structures. A few blocks down at 200 South State Street is the Abbey Players Theater, located in a circa 1910 building once used as a saloon. Visitors can enjoy the long-running theater company productions and the elaborate bar that remains inside.

The Sam Guarino Blacksmith Shop Museum at 304 South State Street contains the working innards of the town's 1913 blacksmith shop that was in operation downtown until 2004. Tours are by appointment only, but living history and educational demonstrations are offered.

The Louisiana Military Hall of Fame and Museum is a new addition to the town, honoring those men and women of Louisiana who have served in the defense of the United States and containing a collection of artifacts, memorabilia and vintage World War II aircraft (lamilitarymuseum.com).

Food lovers will enjoy the many great restaurants in Abbeville, some of which serve up Louisiana seafood fresh from the sea. Abbeville is also home to the C.S. Steen Syrup Mill, which produces Steen's cane syrup (steensyrup. com), and Cajun Power Sauce Manufacturers, which produce jars of goodness such as a gumbo starter that makes Cajun cooking so much easier (cajunpowersauce.com).

PALMETTO ISLAND STATE PARK

This new Louisiana State Park exists about a twenty-minute drive south of Abbeville, named because the park appears as an island of palmetto forest. The park harbors all kinds of migratory and native species of birds, and there are several ponds within the park's boundaries, plus a seven-acre lagoon and cabins alongside a wide stretch of the Vermilion River. Visitors to Palmetto Island can enjoy picnicking, fishing, canoeing and hiking either on a day-use basis or by camping out in the ninety-six primitive RV sites or in one of the brand-new, fully equipped cabins that can sleep eight. The visitor's center also features a nature center, a boardwalk through a wetlands area and hiking trails to ponds. In warm months, the complex turns on a fun splash fountain for kids, and there's a bathhouse for changing. There are two places to launch boats at Palmetto Island: the Vermilion River access and at a two-acre pond for canoeists, the latter of which links to an extensive canoe trail to other ponds and the seven-acre lagoon, not to mention eventually making its way toward the river. In addition, picnic pavilions and meeting spaces can be rented for family reunions and other events.

ERATH

Erath in the eastern portion of Vermilion Parish was founded in 1899 by Swiss immigrant August Erath. The town is home to the impressive Acadian Museum, where the history of the Acadians, from Nova Scotia to Louisiana, is told in various exhibits. The museum also offers history of the region, plus inducts local heroes into its "Living Legends" category. There is a café next door where live music is occasionally performed (acadianmuseum.com).

Erath goes all out for the Fourth of July, with live music, carnival rides, eating contests, barbecue cookoffs and water fights.

Famous Erath natives include Cajun musician D.L. Menard and jockey Randy Romero, the latter of whom was inducted into the Racing Hall of Fame.

RIP VAN WINKLE GARDENS

A dreamy landscape of centuries-old oak trees draped in Spanish moss, a lakeside backdrop and a historic mansion with an intriguing history are what awaits visitors—and brides—at Rip Van Winkle Gardens on Jefferson Island, a short drive from Lafayette. Both the Joseph Jefferson Mansion, listed on the National Register of Historic Places, and the lush surrounding gardens are renowned, making the area one of the best wedding destinations in Louisiana.

The property once called "Orange Island" was purchased by American actor Joseph Jefferson in 1870; it appears as an island because it sits on top of a coastal salt dome surrounded by Lake Peigneur (see also "The Islands" in the third chapter). Jefferson was most known for his worldwide role as Rip Van Winkle in the play he adapted from Washington Irving's tale.

Jefferson built his home here in 1870 at the highest point of the property, providing a dramatic view of the lake. A successor developed the surrounding gardens, naming them "Rip Van Winkle Gardens" in honor of Jefferson.

The property is thought to contain the treasure of privateer Jean Lafitte, smuggler and hero of the Battle of New Orleans, and was the site of one of the strangest environmental disasters in history. In 1980, Texaco began drilling for oil on Lake Peigneur and hit an abandoned portion of the salt mine beneath the waters. The entire lake flowed into the empty salt dome, neighboring streams flowed backward and several lakeside buildings were destroyed. A film of this disaster is available for viewing on the Rip Van Winkle tours.

Today, the grounds are extensively maintained and contain meandering walks, various flowering plants throughout the year and a haven for migrating birds and other wildlife. In addition, the property includes bed-and-breakfast cottages and a restaurant (ripvanwinklegardens.com).

DELCAMBRE

The small town of Delcambre, located on the Vermilion River with access to the Gulf, is home to the annual blessing of the shrimp fleet during the Delcambre Shrimp Festival in August. Two unusual aspects of the town is that it's divided between the parishes of Vermilion and Iberia and that the priest doesn't face the congregation in the town's Our Lady of the Lake Catholic Church because church members never allowed modernization of its altar (vermilion.org/towns/Delcambre).

KAPLAN

This prairie town is home to country musician Sammy Kershaw, Branson musician Cedric Benoit and the old-fashioned, unique krewe of Chic à la Pie Mardi Gras celebration. Throughout the countryside surrounding the town can be found numerous species of birds migrating up through the Mississippi Flyway, making it one of the best places to bird-watch in Louisiana (vermilion.org/towns/Kaplan).

COW ISLAND

Cow Island, a few miles south of Kaplan, was named not for a salt dome rising above eroding marshland but rather a ridge that appeared as an island in the prairie. The ridge at Cow Island was named for the first settlers, who raised cattle. Visitors take Louisiana Highway 35 from Kaplan to reach Cow Island, and along the way they will find Suire's Grocery, a great spot to enjoy wonderful Cajun plate lunches, as well as buying groceries and bait. You can read about the grocery's history in the many articles lining the walls, plus take home frozen entrées, such as turtle sauce picante or shrimp pistolettes, or one of their many freshly made desserts. Farther down the highway is the tranquil Greene Cemetery, followed by great places to spot migratory birds enjoying the Mississippi Flyway every spring and fall (vermilion.org/towns/CowIsland).

Suire's Grocery outside Kaplan is a great spot to enjoy Cajun plate lunches.

FORKED ISLAND

Forked Island (pronounced fork-id by the locals) lies south of Kaplan and northeast of Pecan Island and contains great fishing, good food at bait and tackle shops and an old ferry landing near the junction of Louisiana Highway 82 and Louisiana Highway 35 that's a great place to watch barges on the Intracoastal Canal. Past the Forked Island Bridge is a camp once belonging to Debra Paget, an actress with movie credits such as *Love Me Tender* and *The Ten Commandments* (vermilion.org/towns/ForkedIsland).

RAYNE

The town's name may sound like water falling from the sky, but it was named for B.L. Rayne, the railroad engineer who brought the Louisiana Western Railroad to this western region of the Cajun prairie. Frogs also brought the town fame when the Weill brothers of France began exporting large bullfrogs from the area to be enjoyed in restaurants throughout America

Left: Rayne train depot platforms were used many times for public meetings and political gatherings by Louisiana governor Huey Long, Senator Dudley LeBlanc and Governor Earl K. Long.

Below: Rayne calls itself the "Frog Capital of the World," and visitors will see this tradition in the town's many frog murals, created by award-winning Acadiana muralist Robert Dafford.

(it was a delicacy then). Rayne calls itself the "Frog Capital of the World," and visitors will see this tradition in the town's many frog murals, created by award-winning Acadiana mural artist Robert Dafford. The annual Frog Festival is held in the fall.

An interesting feature of Rayne is the cemetery of St. Joseph's Catholic Church, where graves are buried in a north–south direction instead of the traditional east–west formation. Whether the parishioners were trying to buck the trend or grave planners left their compasses at home the day they laid out the plots, St. Joseph's Cemetery is a rarity, the only Judeo-Christian graveyard of its kind and mentioned in *Ripley's Believe It or Not!*

The Maison Daboval bed-and-breakfast, circa 1892, features antiques, tall ceilings, hardwood floors and a deep claw-footed bathtub. The home and its renovations were featured on HGTV's *If Walls Could Talk* (dabovalbb.com).

GUEYDAN

When land became available around the end of the 1800s in western Vermilion Parish, French immigrant and New Orleans businessman Jean Pierre Gueydan purchased forty thousand acres to grow rice. Later the railroad came through, a town was formed and Gueydan was named after the man who started it all. The lure of successful rice crops, temperate weather and the railroad brought others—such as midwesterners—to Gueydan.

Today, Gueydan still grows rice, but residents alternate those crops with crawfish. The biggest lure to the town these days is the ducks that are attracted to the rice fields, marshes, coastal woods and chèniers, small prairie ridges usually containing oak trees. Gueydan has been nicknamed the "Duck Capital of America" and attracts hunters worldwide, not to mention birders who visit during the annual Mississippi Flyway migrations. In fact, the entire town has been designated a bird sanctuary.

You can read about Gueydan the man, the town's development and much more at the Gueydan Museum, located in the Old Bank of Gueydan. In addition to historical items, including wonderful information about the town's devastating flood when water was trapped *behind* its levee, the circa 1902 museum offers art exhibits, displays of duck decoys and local art for sale.

Other spots to see include the quaint Gueydan City Hall, built in 1936 by then mayor A.O. Douglas, and St. Peters Church Rectory, which was ordered

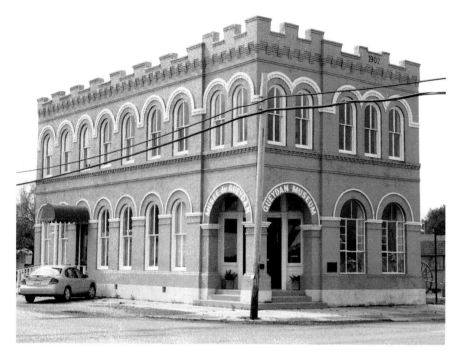

Visitors to the Gueydan Museum, located in the Old Bank of Gueydan, can learn about the prairie town's history and the town's devastating flood and view an extensive display of duck decoys. Gueydan is known as the "Duck Capital of the World" for the migratory birds that visit the surrounding rice fields every year.

from a Sears-Roebucks catalogue in 1918 and built from prefabricated pieces that included a cellar.

Gueydan is located south of Interstate 10, off Louisiana Highway 91 (gueydan.org).

MERMENTAU COVE

The Istre Cemetery in Mermentau Cove offers one of the last remaining examples of the unique Cajun custom of "Petite Maisons," or grave houses. These cypress structures resemble homes that *living* people use—with windows, doors and working locks—but on a smaller scale and located on top of the in-ground grave sites. The houses keep the deceased safe from the elements. The cemetery was established in 1886 and was home to nearly forty of these petite maisons, but today only three remain. South Louisiana

filmmakers Zach and Jeremy Broussard examine these last remaining houses and the culture surrounding them in their documentary *Little Houses*. Proceeds help preserve the remaining structures (www.thelittlehouses.com).

CROWLEY

The growing of rice and raising crawfish dominates the economy of Crowley, home to the International Rice Festival held every October (ricefestival.com). The town was named for Patrick Crowley, an Irish contractor who graded the roadbed for the Southern Pacific Railroad through Acadia Parish. The town owns a delightful historic district featuring numerous Victorian homes and businesses, plus the 1901 Grand Opera House of the South at 505 North Parkenson, a newly renovated and majestic venue for performances and concerts that's reportedly haunted (thegrandoperahouse.org). The downtown also features the historic Rice Theater at 323 North Parkenson Avenue and the Carriage House bed-and-breakfast at 220 East Third Street, a 1902 home listed on the National Register of Historic Places (crowley-la.com).

Rice fields can be found throughout the prairies of Cajun Country.

Roberts Cove

In 1867, Reverend Peter Leonhard Thevis of Langbroich, Germany, was hired to preach to the German immigrants at Holy Trinity Church of New Orleans. Thevis convinced other members of his family to join him in Louisiana, and the family traveled west searching for a new place to settle. They founded Roberts Cove, north of Rayne, and named the town for Benjamin Roberts, the original owner of a Spanish land grant. More German immigrants arrived, creating a unique German influence on the Cajun prairie. Every fall the small town goes out big with its annual Robert's Cove Germanfest on the grounds of St. Leo Catholic Church.

Iota

Iota was once site of a medicinal mineral spring and the early Pointe-aux-Loups health spa. Both the health resort and the waterway Coulé Pointe-aux-Loups were named for wolves seen in area woods ("loups" means "wolves" in English). Another Iota area mineral spring advertised for its health attributes was the Nezpiqué Spring, owned by Francois A. Daigle. Both springs dried up by 1900, possibly due to the irrigation of nearby rice fields.

Today, Iota is known for its traditional Tee Mamou-Iota Mardi Gras Folklife Festival held every Fat Tuesday. In addition to the *courir de Mardi Gras*, or Mardi Gras riders, the festival features traditional French songs, live Cajun and zydeco music and traditional Cajun foods.

Chapter 7
Southwest Louisiana
Lake Charles and Surrounding Parishes

After the Civil War, plans to move railroads west through south Louisiana accelerated. They crossed the Cajun prairie—much where Interstate 10 exists today—completing a continuous line between New Orleans and Houston in 1881. Stations were placed several miles apart, causing towns to spring up around them. The town of Lake Charles and the surrounding area grew with the railroad, enjoying prosperity as products were more easily brought to market. And like other southwestern prairie towns, advertisments in newspapers throughout the country enticed midwesterners and others to share in this abundance and great weather.

The southwestern Louisiana history goes back further than the late 1800s, however, to French settlers in the 1760s and pirates who enjoyed the hidden bays and inlets. It's rumored that the famous privateer Jean Lafitte, notorious smuggler and hero of the Battle of New Orleans, used the southwestern area of Louisiana to stash his treasures; residents today still search just in case. The pirate legacy also spawned Lake Charles's annual Contraband Days Festival, a pirate-styled festival featuring two weeks of music, food and family events in May. In neighboring Sulphur, the mineral of the same name spawned the development of that town. Lake Charles sits within Calcasieu Parish, once a great deal larger and originally named Imperial Calcasieu for its size. As the area grew, the parish was divided into five smaller parishes, and they now include Allen, Beauregard, Calcasieu, Cameron and Jefferson Davis Parishes.

Sunsets are spectacular
over Lake Charles.

LAKE CHARLES

Lake Charles advertises itself as a Cajun town, but its origin involves a variety of heritages. Cajuns settled here in the nineteenth century, moving west from the bayous of south-central Louisiana, but so did midwesterners looking for opportunities and a warmer climate. Texans and others arrived with the oil industry of the twentieth century.

Today, the town attracts people from around the world working at McNeese University and with the many oil and gas companies, but visitors will find great Cajun hospitality, south Louisiana traditions such as a strong Mardi Gras scene, the annual Cajun French Music and Food Festival and plenty of great Cajun cuisine.

The town includes many historic sites, but most are dated after 1910, when the "Great Fire" swept through the downtown area, destroying much

of the city within a short time. The buildings and homes of Lake Charles were constructed of virgin pine, cypress and oak of the surrounding prairie and wetlands, all virtually a tinderbox when the fire began.

A great place to learn of the area's history is the Imperial Calcasieu Museum at 204 West Sallier Street, located on land once belonging to Charles Anselm Sallier, one of the first settlers of the area and the town's namesake. In the rear of the museum is the 375-year-old Sallier live oak tree. The museum spotlights the Imperial Calcasieu region, including the five parishes of Allen, Beauregard, Calcasieu, Cameron and Jeff Davis, and includes items such as Native American artifacts, an old pharmacy, a letter of marque given from King Louis XVI of France to a local pirate and photographs of the Great Fire of 1910 that destroyed most of the town, among much more. The museum also includes the Gibson-Barham Gallery, which exhibits artwork on a rotating basis (www.imperialcalcasieumuseum.org).

The Central School Arts and Humanities Center at 809 Kirby Street, built as a school in 1912 by noted New Orleans architects Favrot and Livaudais, now houses the Mardi Gras Museum of Imperial Calcasieu, the Children's

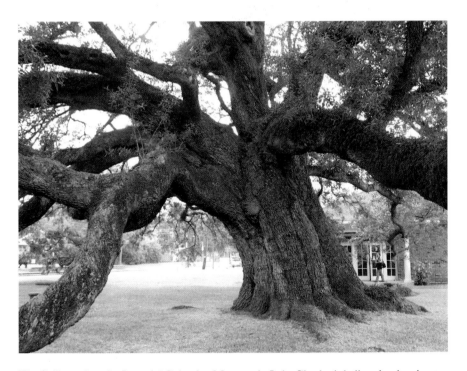

The Sallier oak at the Imperial Calcasieu Museum in Lake Charles is believed to be about 375 years old.

Dozens of Carnival costumes are part of the Mardi Gras Museum located in the Central School Arts and Humanities Center of Lake Charles.

Theater Company, the Lake Charles Symphony, the Art Associates Gallery and the Black Heritage Gallery, among others.

The Mardi Gras Museum is a must stop for anyone wanting to know more about the annual festival with its colorful costumes, balls and parades. Lake Charles is one of several cities in Louisiana with a well-organized Carnival season, and the museum displays many of the Carnival krewes' extravagant costumes, plus offers history on how the city's Carnival began and explains the holiday unique to Louisiana and the surrounding areas of the Gulf Coast.

The 1911 Historic City Hall at 1001 Ryan Street rose from the ashes of the former building destroyed by the Great Fire of 1910. Today, the elaborate Italianate structure designed by New Orleans architects Favrot and Livaudais serves as the City Hall Arts and Cultural Center, showcasing traveling art shows and hosting the Saturday morning farmers' market. The impressive four-face clock operates much like cuckoo clock (cityoflakecharles.com).

Right: The impressive four-face clock of the 1911 Historic City Hall of Lake Charles operates much like a cuckoo clock.

Below: The 1911 Historic City Hall of Lake Charles with its Italianate design rose from the ashes of the former building destroyed by the Great Fire of 1910.

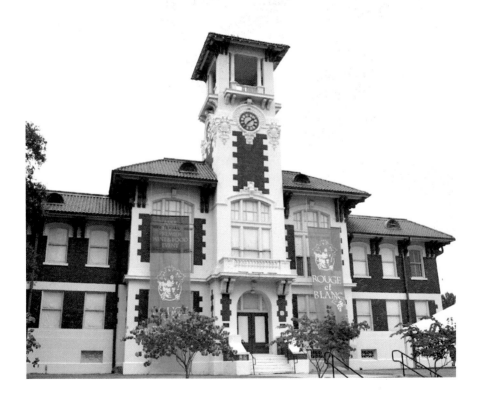

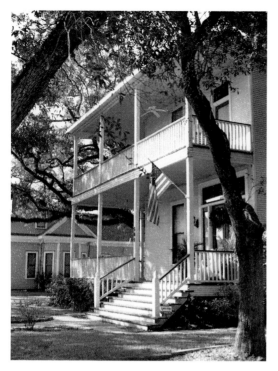

The Charpentier historic district covers forty blocks within downtown Lake Charles, with homes dating back to the 1800s and early 1900s. The district's name reflects the individual styles of the carpenters, or *charpentiers* in French.

The Charpentier historic district covers forty blocks within downtown Lake Charles, with homes dating back to the 1800s and early 1900s, many of which were unique in architecture due to the lack of architects in the city at the time. The district's name reflects the individual styles of the carpenters, or *charpentiers* in French. A great historic guide to the area can be obtained at the Southwest Convention and Visitors Bureau off Interstate 10, or simply park your car and arrange for a guided mule-drawn buggy ride. There are many wonderful ghost stories attached to some of these homes, as well.

McNeese State University, with its many live oak trees and azaleas, was established as a state junior college in 1939 and was later named John McNeese Junior College in honor of John McNeese, a southwest Louisiana educator and the first superintendent of schools in Imperial Calcasieu Parish. McNeese became a four-year college in 1950. Today, the campus features sixty-eight buildings on five hundred acres and includes the original structures of Kaufman Hall, Ralph O. Ward Memorial Gym and Francis G. Bulber Auditorium, the latter an example of Art Deco architecture that's listed on the National Register of Historic Places.

Lake Charles owes its name to Charles Sallier and the fact that it's surrounded by a lake. Along Shell Beach Drive, visitors can view many of the city's finest homes fronting Lake Charles. On one side of the lake lies North Beach, the only white sand beach inland from Texas to Florida and one that is open daily year round, with admission of one dollar per car in the summer months. The beach is located directly off Interstate 10 on North Lakeshore Drive, at Exit 29 for eastbound travelers and Exit 30A for westbound travelers. South of Lake Charles, the newly expanded and redesigned Prien Lake Park is a twenty-nine-acre park overlooking Indian Bay on Prien Lake that includes a Harbor's Edge multiuse pavilion, amphitheater, picnic pavilions, elevated boardwalk, walking paths, playgrounds, SprayGround water park and more. During the fall there's free movies under the stars, and all year long there are canoe and boat launches, plus opportunities to fish.

SAM HOUSTON JONES STATE PARK

Just north of Lake Charles, where the west fork of the Calcasieu River connects with the Houston River, is a lovely state park offering a quiet escape. Sam Houston Jones State Park offers hiking trails, fishing, boating opportunities and a variety of camping options. It's also an excellent place to view wildlife. Deer roam freely, and birds such as great white egrets, herons and redheaded woodpeckers can be easily spotted.

The 1,800-acre park features both wood and cinder block cabins at affordable rates stocked with linens and kitchen utensils. Most cabins offer a variety of sleeping arrangements, such as bunk beds and sleeper sofas, so the cabins make for great weekend outings, retreats or family reunions. Several along the river offer screened porches with chairs. Other camping options are RV slots and tent sites, all located near the lagoons and riverside. And all camp sites include outdoor fire rings.

For hikers, the Old Stage Coach Trail follows along what is believed to be a portion of the Old Spanish Trail that ventured west into what is now Texas. The Old Spanish Trail at Sam Houston State Park follows the Calcasieu River beneath a variety of tree species and a cacophony of bird songs. Because Lake Charles is part of the spring and fall migratory bird path, it is not unusual to spot numerous bird species on the trail during these times. The Old Stage Coach Trail takes a relaxing loop toward the river and then connects to the larger Longleaf Pine Trail, a good two-hour hike that

Above: Sam Houston Jones State Park is home to numerous bird species, deer and other wildlife.

Left: Sam Houston Jones State Park offers fishing, boating opportunities and a variety of camping options, in addition to hiking on the Old Stage Coach Trail.

makes a giant circle of the park. There are several shorter trails that remain close to the camping areas, some of which stick to the river and others that head through the woods (crt.state.la.us/parks/iShjones.aspx).

SULPHUR

Sulphur, as you may have guessed, was named for the mineral found in this location in 1867 as workers were searching for oil. The extraction process was difficult, and five men died trying to bring the mineral to the surface. German chemist Dr. Herman Frasch was successful in extracting the sulphur, and the Union Sulphur Company was soon established. The result was Sulphur being named the "richest fifty acres in the world" at that time.

Company workers were brought in from Germany, Canada and the northern part of the United States to work the mine, and the town boomed, with neighboring forests providing timber for construction of houses, retail establishments and a school. Sulphur ceased being mined in 1924, and today black gold (oil) is the dominant industry, with numerous refineries doting the landscape.

Downtown Sulphur offers several historic buildings and homes in its historic district, including the Brimstone Museum at 900 South Huntington, which offers a history of the Sulphur area in the old Southern Pacific Railroad Depot, and the Henning Cultural Center at 923 South Ruth Street next door, which hosts special events and local and traveling art shows. The building housing the Henning Center is the 1910 home of Reverend John T. Henning, once the owner of a Sulphur rice and cattle farm (brimstonemuseum.org).

Other historic structures to consider is the 1922 Spanish Mission–style Our Lady of Prompt Succor Church at 802 South Huntington and the Sulphur Mines Cottages at 908 Mathilda and 441 Starlin, examples of the employee housing for the sulphur mines. These cottages were built by Aristide Boudreaux of Kaplan and range from small cottages for the laborers to the more spacious homes of the mine administrators. They were moved to this site in the 1950s from their original locations.

DEQUINCY

DeQuincy is an unassuming little town north of Lake Charles that is home to one of the finest railroad museums in the country. Housed in the Kansas City Southern Depot and listed on the National Register of

The DeQuincy Railroad Museum in the southwestern town of DeQuincy features a wide variety of railroad memorabilia in the old Kansas City Southern Depot.

Historic Places, the DeQuincy Railroad Museum features a wide variety of railroad memorabilia. Visitors can enjoy the numerous minature trains on display, items from a bygone time period such as railroad tickets and dining car menus and all kinds of items used by rail men and women years ago when the train service was so important to the lumber town. There are literally thousands of items on view, many of which were donated by the town's citizens. On the museum grounds rest a restored 1913 steam locomotive, a 1947 passenger coach and two vintage cabooses, great opportunities for kids to see old trains up close and personal. There's also a playground, picnic tables and a pavilion for picnics. Admission is free, but donations are accepted, plus there's a great gift shop offering all kinds of railroad fun.

And if that wasn't enough, the museum hosts a fabulous festival every spring. The Louisiana Railroad Days Festival is held the second weekend in April and features a queen's pageant, live music, festival food, parade, carnival rides, arts and crafts and plenty of specialty events.

A Tour of Historic Acadiana

The DeQuincy historic district features many historic buildings and homes, including the 1885 All Saints Episcopal Church, which was moved to DeQuincy from Patterson (cityofdequincy.com).

VINTON

Like many other southwestern towns, Vinton established itself after the railroad came through and after advertisements in newspapers brought settlers in looking for jobs in the timber industry and a temperate climate. There are several historic structures in town, including the 1900 Queen Anne–style Theodore "Ted" Lyons House at 1401 Loree, once home to Chicago White Sox pitcher and inductee into the Baseball Hall of Fame, and the circa 1911 Lane's Pharmacy at 1307 Horridge, still in business and attracting French-speaking clientele enjoying coffee in the mornings.

Outside of Vinton is the Antioch Primitive Baptist Church and Big Woods Cemetery, an original hewn-log church replaced with the primitive building after the Civil War. Niblett's Bluff Park at the end of Niblett's Bluff Road off Highway 109 outside of Vinton was the site of a Civil War encampment known as Fort Nibletts. Today, the park is a tranquil spot to fish, camp in miniature cabins and at RV sites, bird-watch, picnic and hike through nature (niblettsbluffpark.com).

JENNINGS

Right off Interstate 10, at the Louisiana Oil and Gas Park, visitors can spy alligators up close and personal at the Chateau des Cocodries (Alligator House) and get a glimpse into Jennings' past as an oil epicenter. The alligators are housed in an air-conditioned space, with baby alligators available for holding and touching (if you dare). At designated times, visitors can watch the alligators being fed. The park also includes a small lake and a replica of Louisiana's first oil drilling rig. Jennings was the site of the first successful oil well drilled within the Jennings Oil Field in 1901 and considers itself the "Cradle of Louisiana Oil" today.

For a great example of past retail establishments, the W.H. Tupper General Merchandise Museum at 311 North Main Street is a must. W.H. Tupper opened his store in Jennings in 1910. When he closed shop in 1949, the entire inventory was left on the shelves until it was boxed and warehoused

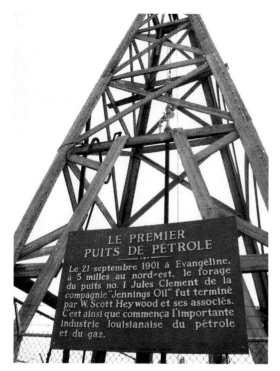

LE PREMIER
PUITS DE PÉTROLE

Le 21 septembre 1901 à Evangéline.
à 5 milles au nord-est, le forage
du puits no. 1 Jules Clement de la
compagnie "Jennings Oil" fut terminé
par W. Scott Heywood et ses associés.
C'est ainsi que commença l'importante
industrie louisianaise du pétrole
et du gaz.

The Louisiana Oil and Gas Park in Jennings offers a replica of Louisiana's first oil drilling rig. Jennings was the site of the first successful oil well drilled within the Jennings Oil Field in 1901 and considers itself the "Cradle of Louisiana Oil" today.

by his grandson in 1971. The store's thousands of contents were donated to the museum and now offer a valuable glimpse back in time, showcasing how a rural general store appeared at the turn of the century and up until around World War II. The museum includes a doll collection, old pharmaceutical bottles and baskets made by the Native Americans of nearby Elton for exchange of items. There's also the Louisiana Telephone Pioneer Museum located within, exhibiting interactive history of the telephone in Louisiana (tuppermuseum.com).

The Zigler Museum at 411 Clara Street has been considered one of the finest art museums in south Louisiana, with the original collection numbering more than two hundred works of art, including the largest private collection of works by African American artist William Tolliver.

Jennings is home to numerous historic places, from elegant homes to old businesses. The Historic Strand Theatre at 432 North Main Street is a 1939-era movie house on the National Register of Historic Places that has been restored and is now used for live performances. Visitors can obtain a brochure that lists these historic structures and their addresses.

ELTON-KINDER

The Coushatta Tribe was a member of the Creek Confederation, inhabiting parts of Mississippi, Alabama and Georgia before being pushed westward after the Creek War of 1813–14. They eventually came to Louisiana, settling in the Elton and Kinder areas. The Coushatta reservation is located north of Elton and includes the Coushatta Casino Resort and other businesses. Despite the tribe's relocation, the Coushattas have maintained their unique language and identity. They hold a Coushatta Powwow every year (coushattacasinoresort.com).

THE CAJUN BOUDIN TRAIL

There's a cheer often heard at Louisiana universities: "Hot boudin, cold couch couch, come on Cajuns, push, push, push!"

Those who have never tasted the unique flavor of hot boudin (pronounced "boo-dan") may be scratching their heads in wonder. For

Hot boudin for sale at the annual La Grande Boucherie des Cajuns in St. Martinville.

Crawfish and boudin are king in Cajun Country, two delicacies that are favorites with locals.

those of us inhabiting south Louisiana, we know only too well the delightful combination of cooked rice and pork enhanced by onions, green peppers and seasonings stuffed first into a meat grinder and then a sausage casing and finally steamed for consumption. Natives enjoy this blond sausage by pushing the soft insides out of its casing or as boudin balls, where the meat mixture is breaded and fried and the casing is eliminated. It's a taste found nowhere else in America.

Boudin can be found throughout Cajun Country but primarily in the southwestern towns of Lafayette, Lake Charles and Opelousas and surrounding areas. For listings of great meat markets and boudin hot spots along the Southern Boudin Trail, sponsored by Tabasco and the Southern Foodway Alliance, visit southernboudintrail.com. For a listing of spots with reviews around the Lafayette area, visit the Cajun Boudin Trail (cajunboudintrail.com). The Southwest Convention and Visitors Bureau of Lake Charles also publishes a list of boudin producers in the Lake Charles area (visitlakecharles.org/things-you-must-see5).

Chapter 8
The Louisiana Coast

The Louisiana coastline stretches from the mouth of the Mississippi to the border with Texas, miles and miles of marshlands, barrier islands, coastal ridges laced with live oak trees known as chèniers and waterways such as bayous, lakes and bays. These fragile wetlands that hug the coast make up between 40 and 45 percent of the U.S. wetlands of the lower forty-eight states. The Lower Mississippi Regional Watershed alone drains a majority of North America down the Mississippi River on its way to the Gulf of Mexico.

Because of flood control and industry development in south Louisiana, the coastline has been deteriorating at a rate of twenty-five square miles each year. Adding to the problem of coastal erosion and subsidence is the threat of hurricanes, which destroy valuable barrier islands and wetlands. These islands, cypress and oak forests and marshlands act as speed bumps to storms, breaking down storm surge as it approaches south Louisiana cities. If the barrier islands and coastal marshlands disappear, the state becomes faced with a dire threat to its existence. Since 1930, more than 1,900 square miles of coastal land has been lost to the sea.

The Louisiana coast is home to more than two hundred bird species such as egrets, roseate spoonbills, herons and bald eagles, the latter of which enjoys its own festival, the Eagle Expo, in February in Morgan City. In the spring and fall, many migratory species fly through Louisiana on the Mississippi Flyway, using the rich wetlands for food and as a resting spot before or after traveling across the massive Gulf of Mexico. The coast is also

The Louisiana coast consists of marshlands that stretch out for miles.

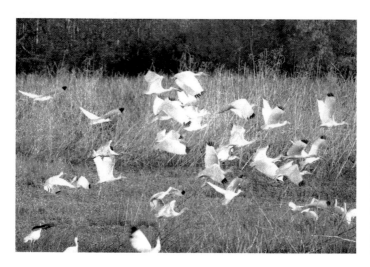

Roseate spoonbills are some of the many bird species found on the Creole Nature Trail.

home to alligators and other native species, plus it is a haven for the state's abundant seafood industry, most of which was harvested for centuries by the state's Cajun population.

We start at the mouth of the Mississippi River and make our way west to the Sabine River and the Texas border. Be sure to bring along a camera—the Louisiana coast is truly a nature lover's paradise.

GRAND ISLE

Grand Isle can easily be considered the last city at the bottom of Louisiana, for even if the small barrier island is geographically not the southernmost part, the winding road needed to get to this remote village will make any traveler feels as if it surely is! Grand Isle is located within Jefferson Parish, a suburban parish of New Orleans that vertically stretches to the Gulf and is reached by traveling to the southern tip of Louisiana Highway 1.

The town of about 1,500 has a colorful and varied history dating back to the 1700s. It's been home to privateer Jean Lafitte and other brigands such as Louis Chighizola, known as Nez Coupé ever since he lost his nose in a knife fight. Outside of piracy and illegal slave trading, the town's main industry focused on the sea, with seafood, alligator hides, turtle meat and bird plumes as major income providers. Today, Grand Isle still relies on the Gulf for its bounty, either through the abundant seafood offerings off its beaches, the offshore oil and gas industries or seasonal tourism. Grand Isle is home to the annual Grand Isle International Tarpon Rodeo and Fourth of July festivities, attracting thousands of tourists each year.

Grand Isle State Park contains ten acres of Gulf beaches, camping and boating facilities and an observation tower that allows visitors a peek over to Fort Livingston on neighboring Grand Terre Island, now separated from Grand Isle by Barataria Pass. Visitors can only travel to Grand Terre Island by boat, but it may be worth the trouble to stand on land once frequented by privateer Jean Lafitte, both a smuggler and hero of the Battle of New Orleans. The United States began work on Fort Livingston as a defense site in the 1840s, but the heavy fortress began sinking into the island's sand, and

The beaches along the coast of Louisiana don't sport pristine white sand and clear blue waters due to the proximity of the Mississippi River, but there are less crowds and more natural elements. It's not uncommon to find lots of flowers and pick up great seashells.

the project was abandoned. Confederates forces took over the complex in preparation of a Union attack but also abandoned the island when news arrived of New Orleans falling to Union forces in the spring of 1862.

Within the historic town of Grand Isle, Our Lady of the Isle Church rings a bell said to have been cast from pirate silver. The church bell rang repeatedly throughout the night during the devastating hurricane of 1893 but then fell into the mire, victim of the storm's fury, like most of the town's structures. It was later salvaged and taken from the island for a time, but it has since been returned to Grand Isle.

Literary aficionados might recall Grand Isle as one of the settings for American author Kate Chopin's novella, *The Awakening*, published in 1899. The story focuses on Edna Pontellier and her awakening sexuality, a controversial book in its day. *The Awakening* is considered a great literary example of early feminism.

CHÈNIERE CAMINADA

Near Grand Isle, a marshland ridge rose above sea level, providing a heavenly place for first native Louisiana peoples, then pirates and, finally, immigrating Europeans and Africans. By 1893, Chèniere Caminada was a bustling fishing village that provided New Orleans with much of its seafood. Residents had cut down much of the area's live oak trees in favor of citrus groves to feed their families, leaving the coastal community vulnerable to the elements. When a major hurricane came ashore in October 1893, more than half of the 1,500 residents perished. Today, the Chèniere Caminada graveyard along Louisiana Highway 1 contains the graves of these victims, including mass grave sites where hundreds of people were quickly buried in the hot sun that followed the storm. Many of Chèniere Caminada's survivors moved to the inland towns of Galliano, Golden Meadow, Cut Off, Lockport and Larose (1893hurricane.com).

PORT FOURCHON

Bayou Lafourche concludes its miles-long journey to the Gulf of Mexico at Port Fourchon, a massive terminal for the oil and gas industries of Louisiana that provide fuel for much of the nation. From this port, heading forty miles offshore, more than six hundred oil platforms dot the Gulf. Port Fourchon is also a hub for commercial and recreational fishing and a great spot for glimpsing migratory birds on the Mississippi Flyway.

Golden Meadow

Golden Meadow hugs Louisiana Highway 1 and Bayou Lafourche, a small fishing village with a large shrimp fleet. The town is the tribal headquarters of the United Houma Nation of Louisiana, a state-recognized tribe that's been fighting for years for federal recognition. The tribe claims seventeen thousand members, according to its website, with residents living within the six parishes of Terrebonne, Lafourche, Jefferson, St. Mary, St. Bernard and Plaquemines (townofgoldenmeadow.com, unitedhoumanation.org).

One of the town's landmarks is *Le Petite Caporal*, an 1854 shrimp boat named for French emperor Napoleon Bonaparte. The historic boat—the oldest in the area—is on dry dock display but was damaged by the recent hurricanes.

Galliano/Cut Off

Settlement began in these coastal towns in the early part of the nineteenth century by Acadians, Italians and French citizens hailing directly from France. The area saw a surge in population after the 1893 Chèniere Caminada hurricane, which sent survivors inland after losing their homes. The Curole House is a good example of the homes built during that time. Although this white wooden house was built by Nicholas Curole *before* the storm, Curole moved and rebuilt the home afterward, and many of the homes built by Chèniere Caminada hurricane survivors reflected the style of Curole's structure. Cut Off was originally named Cote Blanche, meaning "white coast" in English, for the many white houses built around the turn of the twentieth century, but it was changed to Cut Off when a canal was built as a shortcut to New Orleans through Lake Salvador.

Cut Off is home to native Bobby Hebert of the New Orleans Saints, musicians Joe Barry and Jimmie Noone and filmmaker Glen Pitre.

Galliano was named for Italian immigrant Salvador Galliano.

Montegut

Montegut was settled by Acadians along Bayou Pointe-au-Chien in the latter part of the eighteenth century but was later named for Confederate colonel Gabriel Montegut, a local planter. The town is home to the state-recognized Pointe-aux-Chien Indian Tribe and adjacent to the thirty-five-thousand-acre Pointe-aux-Chien Wildlife Management Area.

ISLE DE JEAN CHARLES

Isle de Jean Charles was settled primarily by members of the Biloxi-Chitimacha tribe, French-speaking people who lived off the marshlands and bays of lower Terrebonne Parish as fishermen and trappers. Many residents who lived on the narrow ridge between Bayou Terrebonne and Bayou Pointe-aux-Chene, almost surrounded by water with one road in and out, traveled to school or work by boat or during times of high water. The census of 1910 listed seventy-seven people, all fishermen, oystermen or trappers. Today, the area has been compromised by saltwater intrusion due to coastal erosion and hurricane damage from Hurricanes Katrina, Rita and Gustav, and many of the residents have left Isle de Jean Charles.

CHAUVIN

Bricklayer Kenny Hill settled in the small bayou town of Chauvin in 1988, erecting a tent on a bayou-side lot while he built his home. Then, in 1990,

he started creating pieces of concrete sculptures throughout the property, mainly those with a religious tone or with a biblical reference. There are angels and other celestial figures, a forty-five-foot-tall lighthouse made up of seven thousand bricks, cowboys, soldiers and the artist himself, sometimes expressing a conflict between good and evil. Hill didn't create these folk art pieces to share with others. He called his work a "story of salvation," according to Nicholls State University, which now owns the property. By 2000, when he was evicted for not keeping the grass and weeds down, he was dismayed by religion and reportedly knocked the head of Jesus off a statue when he left.

The Chauvin Sculpture Garden and Art Studio contains more than one hundred pieces of folk art on a small plot of land, the product of reclusive bricklayer Kenny Hill.

The Kohler Foundation purchased the property, which has been gifted to Nicholls State in Thibodaux and is now the Chauvin Sculpture Garden and Art Studio. The site at 5337 Bayouside Drive is open to the public from dawn to dusk, but the NSU Folk Art Studio's hours vary; call 985-594-2546 or the Nicholls State University Division of Art at 985-448-4597 (nicholls. edu/folkartcenter).

COCODRIE

This remote village due west of Grand Isle and connected to Houma by Louisiana Highway 56 consists of numerous fishing camps raised high above the flood-prone marshlands. The impact of the oil and gas industries can be seen here, as well as the presence of the Louisiana Universities Marine Consortium (LUMCON), formed in 1979 to coordinate collegiate marine research and education.

Cocodrie consists of numerous fishing camps raised high above the flood-prone marshlands and the Louisiana Universities Marine Consortium (LUMCON), formed in 1979 to coordinate collegiate marine research and education.

MORGAN CITY

Morgan City lies at the bottom of the vast Atchafalaya Basin, the largest freshwater river swamp basin in North America; the basin covers almost one-third of Louisiana. Draining through the heart of the basin is the 135-mile Atchafalaya River, which terminates at Morgan City. Originally, the town was named Tiger Island for the large cats seen in the area wilderness. Later, the town was renamed Brashear City for Walter Brashear, an area sugar mill owner and physician who hailed from Kentucky. In 1876, the town became Morgan City for steamship magnate Charles Morgan, who dredged the Atchafalaya River, an action that allowed the town to grow as a sea port and trading hub.

Twelve blocks make up the historic district fronting the Atchafalaya River and points south to the Gulf of Mexico, appropriate for a town known for both its long relationship with the seafood industry and oil and gas. Naturally, the historic district comes alive every Labor Day weekend for the massive Louisiana Shrimp and Petroleum Festival, which includes the long-standing "Blessing of the Fleet" by priests to participating shrimp trawlers. Attractions within the historic district include the International Petroleum Museum and Exposition at 111 First Street, which offers visitors a chance to experience an offshore drilling rig and learn about the oil industry both past and current (rigmuseum.com); the historic Sacred Heart Catholic Church, Trinity Episcopal Church and Pharr Chapel Methodist; and many lovely old homes and buildings (morgancitymainstreet.com). The downtown area is protected by a twenty-one-foot seawall, known as the "Great Wall," which offers a lovely view of the Atchafalaya River.

Just outside of town on Louisiana Highway 70 is the 106-foot-tall Carillon Tower nestled inside ten acres of Brownell Memorial Park on Lake Palourde. The bell tower or carillon rings sixty-one bronze bells every quarter hour throughout the peaceful oasis that is also considered a bird sanctuary and naturalist haven. Both the tower and nondenominational park, dedicated and opened to the public in 1972, were the creation of Claire Horatio Brownell and her nephew, Dr. C.R. Brownell, early settlers of the area. The free park is open from 9:00 a.m. to 4:00 p.m. Wednesdays through Sundays.

Lake Palourde, meaning "clam" in French due to the abundance of clams found along its shores, stretches out for seventeen square miles and offers fishing opportunities, hiking, bird-watching and photography.

The first *Tarzan of the Apes* film, made in 1918, was filmed in the swamps near Morgan City. Before Hollywood was discovered as the perfect seasonal

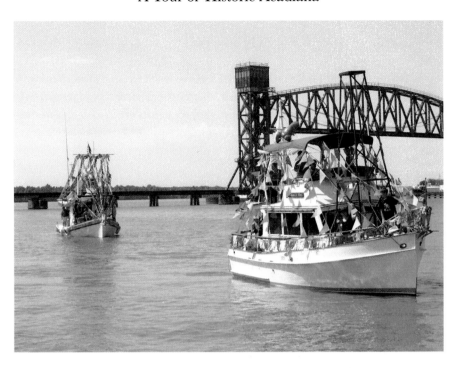

Above: Every Labor Day
weekend, Morgan City packs
in tourists for the Shrimp and
Petroleum Festival, one the
oldest and largest festivals in
Louisiana.

Right: Trinity Episcopal
Church in Morgan City,
founded in 1874, is part of the
historic downtown riverfront
and one of the oldest churches
in eastern St. Mary Parish.

spot to make films year round, Louisiana was a strong contender. Many silent films were produced in the state about the time of *Tarzan*. Other films made around Morgan City include *Thunder Bay* with Jimmy Stewart, which showcased the conflicts between the oil industry and local fishermen; *All the King's Men*, starring Sean Penn and Jude Law; and *The Curious Case of Benjamin Button*, with Brad Pitt and Cate Blanchett, to name a few.

BERWICK

Berwick is a Cajun Coast town settled by a Pennsylvania immigrant, Thomas Berwick. The town fronts the lovely Atchafalaya River with a convenient walkway along the river's edge, complete with trademark red lighthouse. The dock was the setting for *The Yellow Handkerchief*, starring William Hurt. The town is home to boat companies, seafood processing plants and others who make their living off the sea (townofberwick.org).

The Atchafalaya River runs through Berwick, Morgan City and other coastal towns.

PATTERSON

This quaint town in the heart of the Cajun Coast was settled by Pennsylvanian Dutchman Hans Knight. Originally called Dutch Settlement, Dutch Prairie and Dutch Town, the town changed its name to Pattersonville in 1832 for prominent citizen Captain John Patterson, who moved to the area from Indiana and acquired a post office for the town. In 1907, the town was renamed to Patterson.

The largest cypress sawmill in the world existed within Patterson, owned by Frank B. Williams, father to equally prominent sons: philanthropist Kemper Williams, who supported the Historic New Orleans Collection and for whom was named the Kemper Williams Park and Campground in Patterson, and Harry Williams, who along with Jimmie Wedell developed the Wedell-Williams Air Service in 1928, servicing charter planes to New Orleans and breaking speed records in competition. Williams married Broadway and silent screen star Marguerite Clark, who sold the business after the death of both men to Eddie Rickenbacker, owner of Eastern Airlines.

The Louisiana State Museum in Patterson at 118 Cotton Road houses collections explaining both the area's aviation and cypress sawmill industries. The Wedell-Williams Aviation Collection features historic information about aviation pioneers Wedell and Williams. The Patterson Cypress Sawmill Collection documents the history of the cypress lumber industry in Louisiana and features a variety of artifacts, photographs and film in addition to the changing exhibit space (lsm.crt.state.la.us/wedellex.htm).

FRANKLIN

More than four hundred historical properties make up Franklin's historic district, a town in which many Americans settled after the Louisiana Purchase of 1803 and developed sugar plantations and commerce along the lower Bayou Teche (franklin-la.com). The town was founded in 1808, incorporated in 1820 and named for Benjamin Franklin. Some of the impressive homes to be found in and around Franklin include the monumental 1837 Oaklawn, used in the Paul Newman and Joanne Woodward film *The Drowning Pool* and once home to Louisiana governor Mike Foster (oaklawnmanor.com), and the circa 1851 Greek Revival–style Grevemberg House and Museum, filled with antiques (grevemberghouse.com). Franklin also features tours of homes throughout the year.

CHARENTON

Members of the Chitimacha tribe were the original inhabitants along this stretch of Bayou Teche, establishing themselves in south Louisiana about the time of the fall of Rome (AD 500). The tribe faced attacks by the colonizing French and other tribes, retreating to the Charenton area, where they forced a stronghold on their land. The tribe sued the U.S. government for confirmation of this property, and a resulting reservation of more than a thousand acres was established. Today, the tribe holds fast to their traditions and land, running the Chitimacha Museum and Cypress Bayou Casino.

The Chitimacha Museum at 3289 Chitimacha Trail offers an overview of the tribe's history from its origins six thousand years ago to today, with various artifacts and modern exhibits, as well as a showcase of the tribe's famous basket-weaving skills. Admission is free (chitimacha.gov). Cypress Bayou Casino is the casino owned by the sovereign nation of the Chitimacha at 832 Martin Luther King Road in Charenton and contains 1,200 slot machines and more than forty table games, plus award-winning restaurants (cypressbayou.com).

The Charenton Heritage Museum at 3041 Chitimacha Trail includes the history of both the town and the neighboring Bayou Teche and Atchafalaya Basin waterways, among many other exhibits. Tours are available by appointment.

PECAN ISLAND

Pecan Island (La Pacanière) appears as an island among the marshland grasses of south Louisiana, but it's not surrounded by water. Instead, the small coastal community consists of ridges, called chèniers in Louisiana, that rise up above sea level, much like an island would at sea. The remote lower Vermilion Parish town was named for its abundance of pecan trees and is a favorite weekend spot of hunters and fishermen.

Jacob Cole was considered the first settler of Pecan Island—a Texan moving eastward in search of grazing land for his cattle and the name provider of the town. Cole found mostly alligators and mosquitoes at Pecan Island but also a discovery that has lingered on as a legend to this day: Cole claimed to have found a pile of human bones.

"The island is said to be like unto the valley of dry bones, a veritable Golgotha, and that great quantities of human bones are to be found here," wrote historian William Henry Perrin.

The Intracoastal Canal cuts through south Louisiana near Pecan, Forked and Cow Islands.

The area was used in the 1985 film *Belizaire, the Cajun*, starring Armand Assante.

Today, many people call the community home, although Hurricanes Rita and Ike made coastal living dangerous; the Pecan Island High School closed after Hurricane Rita.

HOLY BEACH

This Gulf-side resort was once known as the "Cajun Riviera," although many people chuckle when they use that phrase. Made up of family camps, juke joints and dance halls, Holy Beach was not exactly Miami Beach. But residents of southwest Louisiana hold a special place in their hearts for the Cajun Riviera, now just a memory after Hurricane Rita washed most of the homes away. Today, Holy Beach is being resurrected, mainly with camps raised high above the incoming tide and with a more modern flare to their architecture. Hope remains high that the quaint village will return.

The town of Cameron took a beating from Hurricanes Rita and Ike, but the resiliency of the people has kept it going.

CAMERON

The southwest coastal town of Cameron has taken many blows by visiting hurricanes. Hurricane Audrey destroyed much of the town in 1957, and Hurricane Rita wiped out the entire southwest corner in 2005, only to be flooded again by Hurricane Ike in 2008. Cameron's population was close to two thousand in the 2000 Census; by the 2010 Census it had dropped to about three hundred. Residents of this area have a tenacious spirit, however, and many have returned to rebuild time and again. The area is a staging ground for offshore oil and gas production, which keeps the local industry wheels turning. Still standing today is the Cameron Courthouse, built about 1937–38. The town and the parish were named for Simon Cameron, President Abraham Lincoln's secretary of war.

CREOLE NATURE TRAIL

The Creole Nature Trail extends down from Interstate 10 from the east and west of Lake Charles, making a large dip to the south and looping back up the other side. The entire route includes 180 miles of wild marshes, wildlife

refuges, bird rookeries, fishing opportunities and beaches where the trail hits the Gulf of Mexico. And if the weather's right, it's possible to view possibly Louisiana's largest collection of alligators in the wild, stretched out in the sun along the roadway or at the Rockefeller Wildlife Refuge, which contains the highest alligator nesting densities in the United States.

The trail is a stopping point for thousands of migratory birds and millions of butterflies along the trans-Gulf migration path, or what most people refer to as the Mississippi Flyway, which is why the

Alligators can be spotted alongside the roadways throughout south Louisiana, but the Creole Nature Trail near Lake Charles has more than its share.

trail is routinely named one of the finest bird-watching spots in the nation. At the center of the trans-Gulf migration path on the edge of the Gulf of Mexico lies Peveto Woods, a unique chènier (oak grove) habitat that's a butterfly sanctuary.

The Creole Nature Trail includes three national wildlife refuges and one state refuge, including the Cameron Prairie National Wildlife Refuge with its visitor's center, exhibits, the three-mile Pintail Wildlife Drive that offers a glimpse into fragile and fascinating marsh life and a boardwalk outside the center that overlooks an area teeming with birds.

There are many places to fish and crab along the Creole Nature Trail, and hunting includes deer, geese, ducks and wild dove, among other game.

At the bottom of the trail, at the south end of the loop, lies twenty-six miles of Gulf Coast beaches, where visitors can swim in the tepid waters or collect seashells along the shore. Because of its proximity to the Mississippi River, the water here is not as blue and clear as in Florida, but chances to find treasure are greater due to fewer visitors (creolenaturetrail.org).

This page: The Louisiana coast offers beaches with less crowds and more natural settings.

Appendix I

Cajun Festivals
and Events

Acadian Memorial Festival
Evangeline Oak Park, St. Martinville
cajuncountry.org/festivals.html

Alligator Festival
Luling
stcharlesrotary.com

Atchafalaya Basin Festival
Henry Guidry Memorial Park, Henderson
atchafalayabasinfestival.com

Atchafalaya Catfish Festival
Melville
cajuntravel.com/festivals

Bayou Teche Bear Festival
Franklin
bayoutechebearfest.org

Black Pot Festival
Acadian Village, Lafayette
blackpotfestival.com

Bon Mangé Festival
Gheens
laffnet.org

Boudin Cookoff
Lafayette
boudincookoff.com

Breaux Bridge Crawfish Festival
Breaux Bridge
bbcrawfest.com

Cajun Music and Food Festival
Lake Charles
cfmalakecharles.org

Catfish Festival
Des Allemands
louisianacatfishfestival.com

Church Point Buggy Festival
Church Point
churchpointbuggyfestival.com

Cochon de Lait
Mansura
cochondelaitfestival.com

Contraband Days
Lake Charles
contrabanddays.com

Coushatta Powwow
Elton
coushattapowwow.com

Cracklin Festival
Port Barre
portbarrecracklinfestival.com

Creole Zydeco Festival
St. Martinville
cajuncountry.org/festivals.html

Delcambre Shrimp Festival
Delcambre
shrimpfestival.net

Eagle Expo
Morgan City
cajuncoast.com/public/events/eagleexpo

Etouffee Festival
Arnaudville
johnfrancisregis.net/etouffee_festival.html

Evangeline Oil and Gas Festival
Evangeline

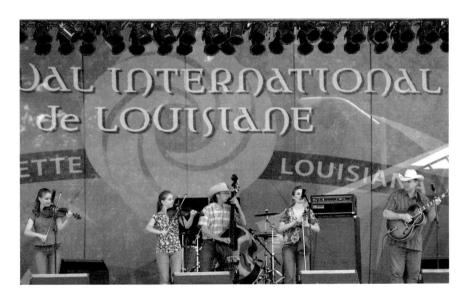

Festival International de Louisiane is a Francophone festival held the last weekend in April in Lafayette, with free live music on several downtown stages, arts and crafts, food and special events.

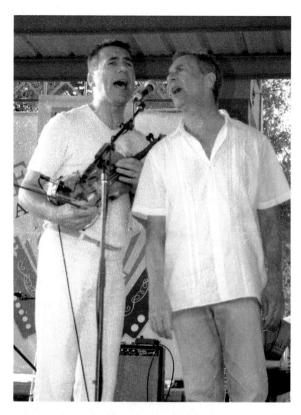

Left: Zachary Richard, *right*, of Lafayette performs with the band 1755 from New Brunswick at the annual Festivals Acadien et Créole in Lafayette.

Below: The band 1755 from New Brunswick performs at the annual Festivals Acadien et Créole in Lafayette.

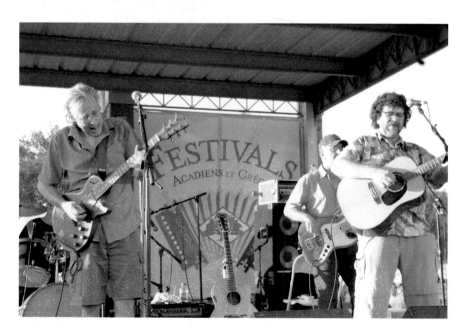

Right: The annual Festivals Acadien et Créole in Lafayette occurs every October and features numerous Cajun and zydeco bands, plus arts and crafts, cultural workshops and great Cajun food.

Below: The Festivals Acadien et Créole in Lafayette.

Appendix I

Festival International de Louisiane
Lafayette
festivalinternational.com

Festivals Acadiens et Creoles
Lafayette
festivalsacadiens.com

Fire and Water Celebration (Le Feu et l'Eau)
Arnaudville
fireandwater.homestead.com

French Food Festival
Larose
bayoucivicclub.org

Frog Festival
Rayne
rayne.org

Germanfest
Robert's Cove
robertscovegermanfest.com

Giant Omelette Celebration
Abbeville
giantomelette.org

Grand Isle Tarpon Rodeo
Grand Isle
tarponrodeo.org

Gueydan Duck Festival
Gueydan
duckfestival.org

International Cajun Joke-Telling Contest
Opelousas
http://zydecocajunbyway.com/festivals.html

International Rice Festival
Crowley
ricefestival.com

Jambalaya Festival
Gonzales
jambalayafestival.org

La Grande Boucherie des Cajuns, Inc.
St. Martinville
cajuncountry.org/festivals.html

Larose Regional Park and Civic Center
Larose
bayoucivicclub.org

Lebeau Zydeco Festival
Lebeau
http://zydecocajunbyway.com/festivals.html

Le Cajun Award and Festival
Lafayette
cajunfrenchmusic.org/lecajun.html

Louisiana Catfish Festival
Washington
townofwashingtonla.org

Louisiana Cattle Festival
Abbeville
louisianacattlefestival.org

Louisiana Gumbo Festival
Chackbay
lagumbofest.com

Louisiana Railroad Days
DeQuincy
larailroaddaysfestival.com

Louisiana Sugar Cane Festival
New Iberia
hisugar.org

MARDI GRAS
Carnival D'Acadie in Crowley, crowley-la.com/carnival.html
Courir de Mardi Gras Church Point, churchpointmardigras.com
Courir de Mardi Gras Eunice, eunice-la.com/festivals.html
Courir de Mardi Gras Mamou, web.lsue.edu/acadgate/mammardi.htm
Mardi Gras in Houma, houmatourism.com
Mardi Gras in Lafayette, lafayettetravel.com
Mardi Gras in Lake Charles, swlamardigras.com
Tee-Mamou-Iota Mardi Gras Folklife Festival in Iota, iotamardigras.com

National Day of the Acadians (August 15)
Acadian Memorial, St. Martinville
cajuncountry.org/festivals.html

Okra Festival
Evangeline Oak Park, St. Martinville
cajuncountry.org/festivals.html

Old Time Boucherie
Eunice
web.lsue.edu/acadgate/eunmard.htm

Opelousas Spice and Music Festival
Opelousas
opelousasspiceandmusicfestival.com

Patterson Cypress Sawmill Festival
Patterson
cypresssawmill.com

Pepper Festival
St. Martinville
stmartinkiwanis.org/pepperfest.htm

Prairie Cajun Folklife Festival
Eunice
eunice-la.com/festivals.html

St. John Andouille Festival
LaPlace
stjohnla.us/andouillefestival.asp

St. Lucy Festival of Lights and KC Christmas Parade
St. Martinville
cajuncountry.org/festivals.html

Shrimp and Petroleum Festival
Morgan City
shrimp-petrofest.org

Smoked Meat Festival/La Festivale de la Viande Boucanee
Ville Platte
smokedmeatfestival.com

Sorrento Boucherie Festival
Sorrento
eatel.net/~fred/boucherie

Southwest Louisiana Zydeco Music Festival
Plaisance
zydeco.org

Sunset Herb and Garden Festival
Sunset
sunsetherbfestival.com

Washington Catfish Festival
Washington
townofwashingtonla.org

World Championship Crawfish Étouffée Cookoff
Eunice
eunice-la.com/festivals.html

World Championship Gumbo Cookoff and Food Festival
New Iberia
worldchampionshipgumbocookoff.blogspot.com

Yambilee Festival
Opelousas
yambilee.com

Zydeco Extravaganza
Opelousas
zydecoextra.com

Appendix II

Cajun Country Tourism Websites

Acadia Parish Tourist Commission, acadiatourism.org.

Acadian Museum in Erath, acadianmuseum.com.

Acadian Village in Lafayette, acadianvillage.org.

Ascension Parish Tourism, ascensiontourism.com.

Assumption Parish Tourism, assumptionla.com/tourism.

Avoyelles Parish Commission of Tourism, travelavoyelles.com.

Bayou Lafourche Area Convention and Visitors Bureau, visitlafourche.com.

Cajun Coast Visitors and Convention Bureau, cajuncoast.com.

Cameron Parish Tourist Commission, cameronparishtouristcommission.org.

Center for Cultural and Eco-Tourism, University of Louisiana at Lafayette, ccet.louisiana.edu/tourism-cultural.html.

City of Scott, cityofscott.org.

Creole Nature Trail, creolenaturetrail.org.

Evangeline Parish Tourist Commission, evangelinetourism.com.

Grand Isle Tourist Commission, grand-isle.com.

Houma Area Convention and Visitors Bureau, houmatravel.com.

Iberia Parish Convention and Visitors Bureau, iberiatravel.com.

Iberville Parish Tourist Commission, visitiberville.com.

Jean Lafitte National Historic Park and Preserve, nps.gov/jela.

Jefferson Davis Parish Economic Development and Tourist Commission, jeffdavis.org.

Lafayette Convention and Visitors Commission, lafayettetravel.com.

Lafourche Parish Tourist Commission, lafourche-tourism.org.

Louisiana Department of Culture, Recreation and Tourism, louisianatravel.com.

Savoy's Music Center, savoymusiccenter.com.

Southwest Louisiana Convention and Visitor's Bureau, visitlakecharles.org.

St. Landry Parish Tourist Commission, cajuntravel.com.

St. Martin Parish Tourist Commission, cajuncountry.org.

Thibodaux (Bayou Lafourche Area Convention and Visitors Bureau), visitlafourche.com.

Vermilion Parish Tourist Commission, vermilion.org.

Vermilionville in Lafayette, vermilionville.org.

Zydeco Cajun Prairie Scenic Byway, zydecocajunbyway.com.

Bibliography

Bernard, Shane K. *Cajuns and Their Acadian Ancestors.* Jackson: University Press of Mississippi, 2008.

Bradshaw, Jim, and P.C. Piazza. *Our Acadiana: A Pictorial History of South Louisiana.* Lafayette, LA: Thomson South, 1999.

Butler, Anne, and Henry Cancienne. *LA 1.* Lafayette: University of Louisiana at Lafayette Press, 2010.

Guilliot, O.C. "Dan." *Images de Lafayette: A Pictorial History.* Lafayette, Louisiana, 1992.

Hardy, Arthur. *Mardi Gras in New Orleans: An Illustrated History.* New Orleans, LA: Arthur Hardy Enterprises, 2007.

Hollier, J. Harold. *Broussard, Louisiana: A Brief History, 1765–1991.* Broussard: City of Broussard, Louisiana: 1984.

Kane, Harnett T. *The Bayous of Louisiana.* New York: Bonanza Books, 1943.

Mamalakis, Mario. *If They Could Talk: Acadiana's Buildings and Their Biographies.* Lafayette, LA: Lafayette Centennial Commission, 1983.

Olinger, Tony, and Cheryl Richard McCarty. *Rayne's People and Places: Images of America.* South Carolina: Arcadia Publishing, 2006.

Robinson, Charles M. *Roadside History of Louisiana.* Missoula, MT: Mountain Press, 2007.

Sternberg, Mary Ann. *Winding Through Time: The Forgotten History and Present-day Peril of Bayou Manchac.* Baton Rouge: Louisiana State University Press, 2007.

About the Author

C heré Dastugue Coen is an award-winning journalist, instructor of writing, playwright, novelist and cookbook author. A native of New Orleans, Cheré now makes her home in Lafayette, Louisiana. Her books include the cookbook travelogue *Cooking in Cajun Country* with "Cajun" Karl Breaux and *Magic's in the Bag: Creating Spellbinding Gris Gris Bags and Sachets* with Jude Bradley. Visit her website at www.louisianabooknews.com.

Visit us at
www.historypress.net